Old-Fashioned SILHOUETTES

942 COPYRIGHT-FREE ILLUSTRATIONS

Selected and Arranged by

Carol Belanger Grafton

DOVER PUBLICATIONS, INC.
New York

Copyright © 1993 by Dover Publications, Inc.
All rights reserved under Pan American and International Copyright Conventions.

Published in Canada by General Publishing Company, Ltd., 30 Lesmill Road, Don Mills, Toronto, Ontario.
Published in the United Kingdom by Constable and Company, Ltd., 3 The Lanchesters, 162–164 Fulham Palace Road, London W6 9ER.

Old-Fashioned Silhouettes: 942 Copyright-Free Illustrations is a new work, first published by Dover Publications, Inc., in 1993.

DOVER *Pictorial Archive* SERIES

Manufactured in the United States of America
Dover Publications, Inc., 31 East 2nd Street, Mineola, N.Y. 11501

Library of Congress Cataloging-in-Publication Data

Old-fashioned silhouettes : 942 copyright-free illustrations / selected and arranged by Carol Belanger Grafton.
 p. cm. — (Dover pictorial archive series)
 ISBN 0-486-27444-6
 1. Silhouettes. I. Carol Belanger Grafton. II. Series.
NC910.043 1993
741.7—dc20
 92-36762
 CIP

Publisher's Note

THE TERM "silhouette"—designating, in the most general sense, an outline filled in with a flat color—derives from the name of a notoriously parsimonious French controller-general of finance, Etienne de Silhouette (1709–1767), who would amuse himself by cutting out paper shadow portraits. The art itself, however, dates back to the Stone Age, and is evident in limestone-cave murals in France and Spain. These Paleolithic designs are remarkably accurate depictions of the natural world: the artist's method was to trace the outline of an object's shadow. Profile drawing later flourished in the religious art and pottery decoration of, among others, the Mesopotamians, the Greeks and the Etruscans. In seventeenth-century Europe shadow portraits—the subject's shadow would be cast onto a wall or screen using a candle or lamp as a light source—were painted on various materials, including wax, plaster and vellum, then elaborately mounted and framed. With the more general availability of paper in the eighteenth century, silhouettes were often cut freehand directly from life. The art became fashionable in both Europe and America, and numerous important collections, including Goethe's, were formed. Among the most important modern silhouette artists are John Miers (1756–1821), August Edouart (1769–1861) and Arthur Rackham (1867–1939).

The present volume, which complements Carol Belanger Grafton's two previous collections, *Silhouettes* (Dover 23781-8) and *More Silhouettes* (Dover 24256-0), contains 942 illustrations taken from numerous nineteenth- and early twentieth-century sources, including *Punch, Harper's Magazine, Harper's Weekly, The Studio, Fliegende Blätter* and *Jugend*.

Contents

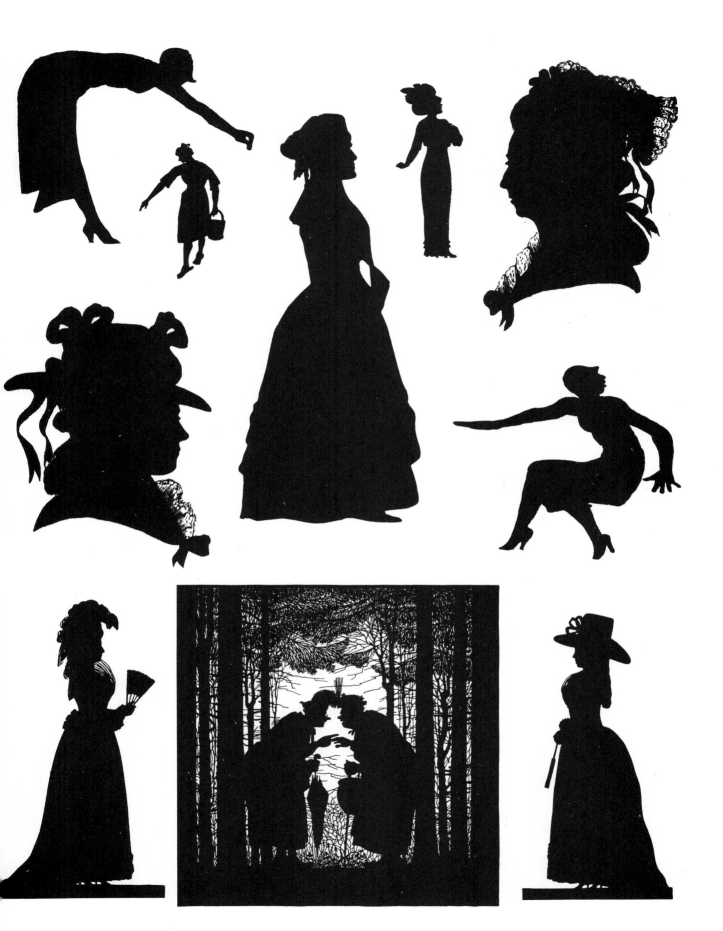

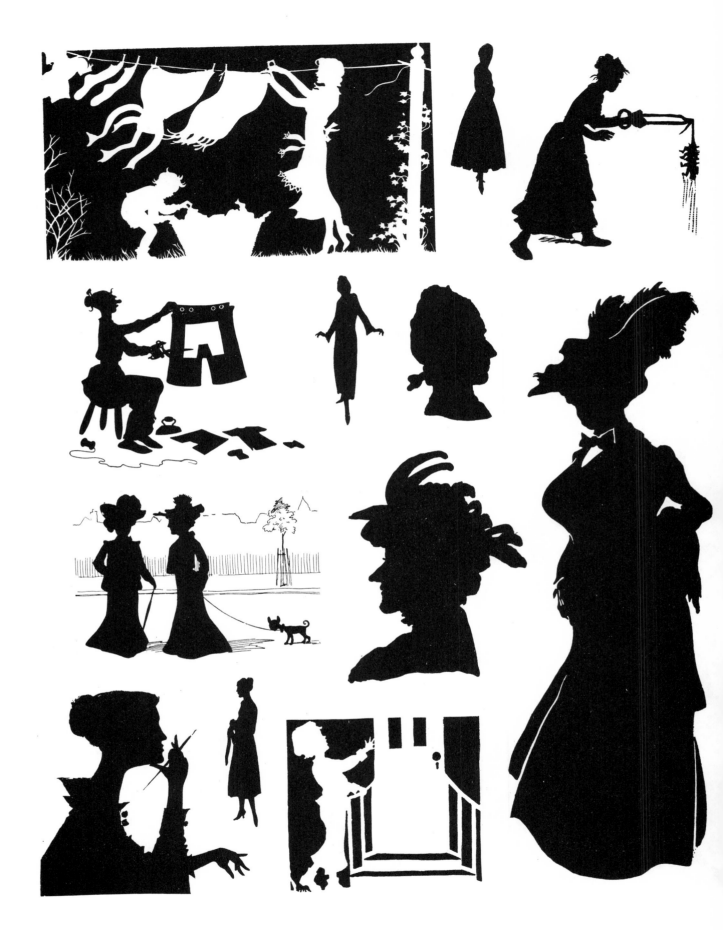

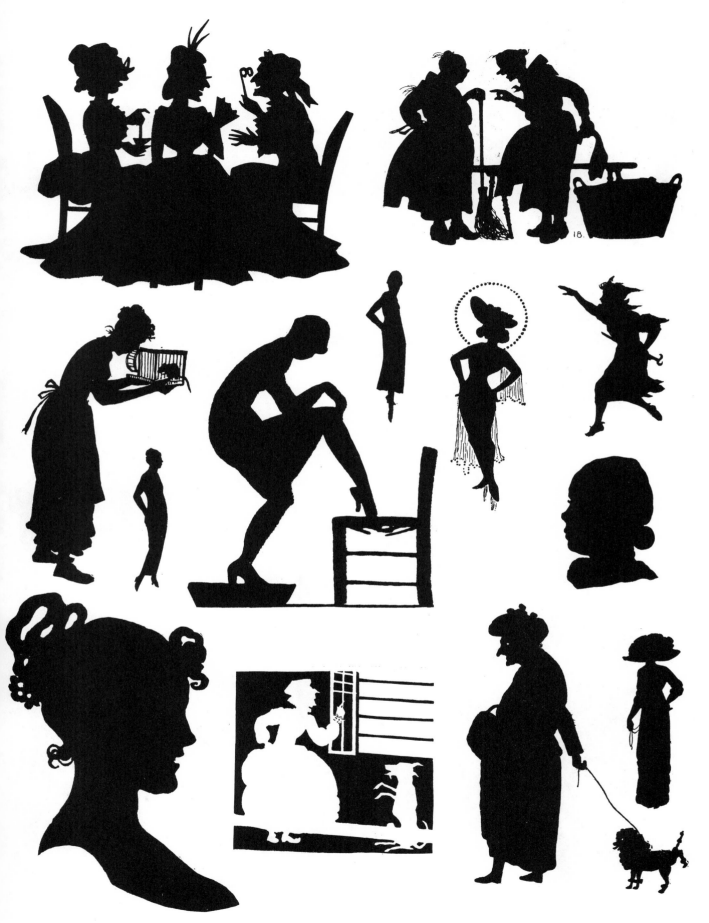

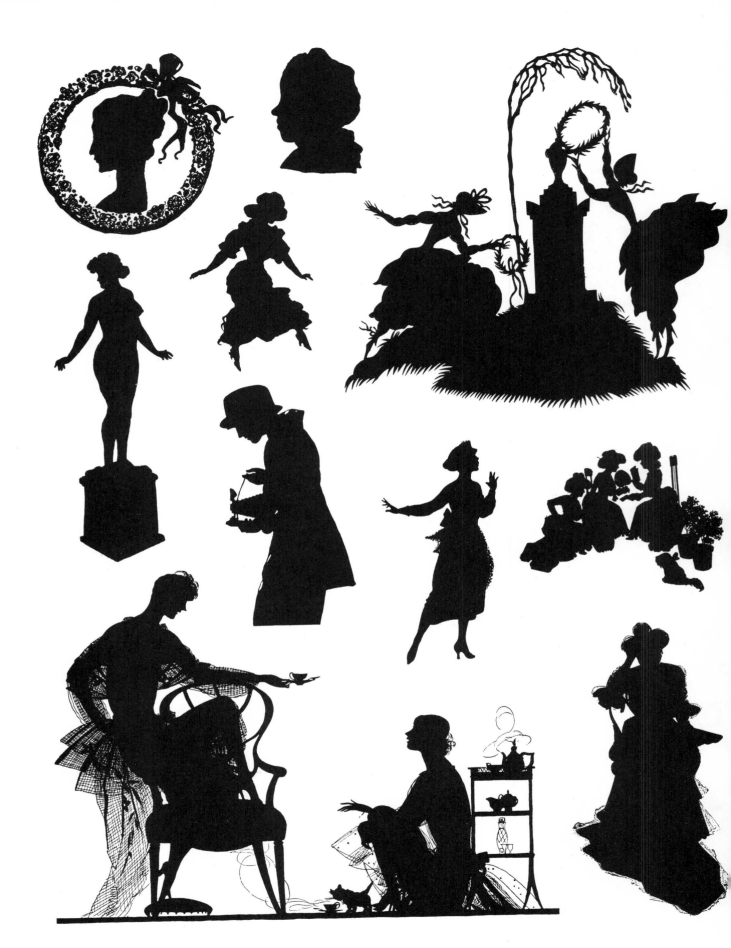

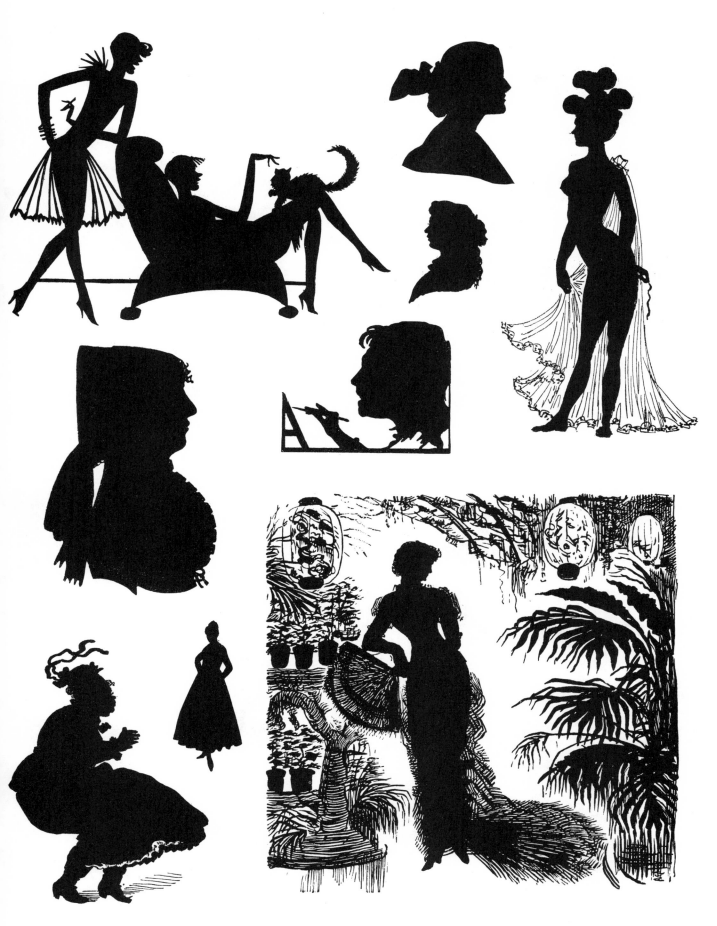

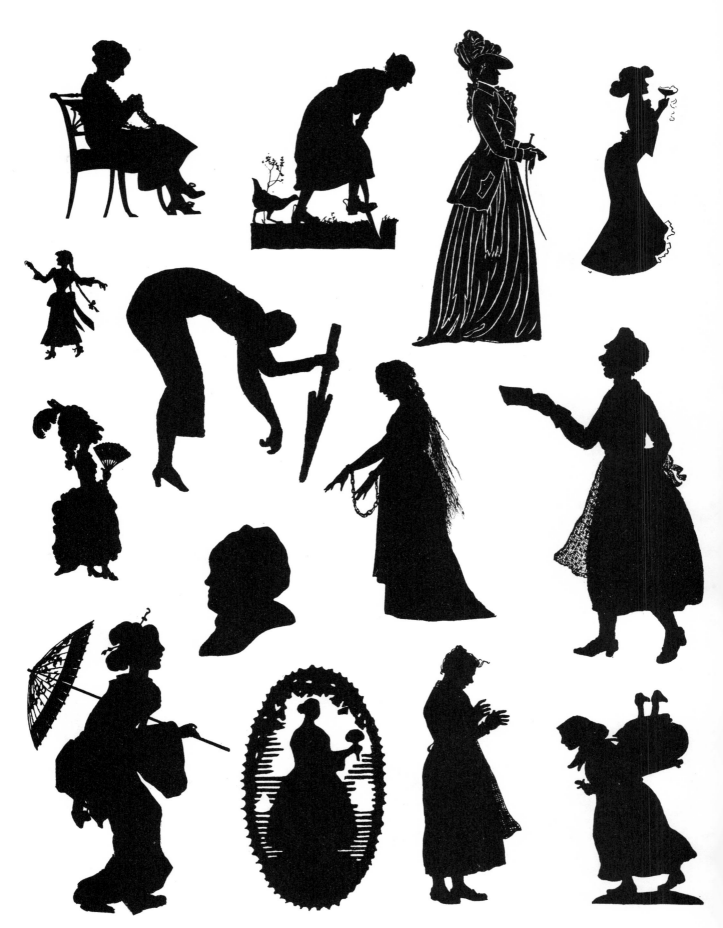

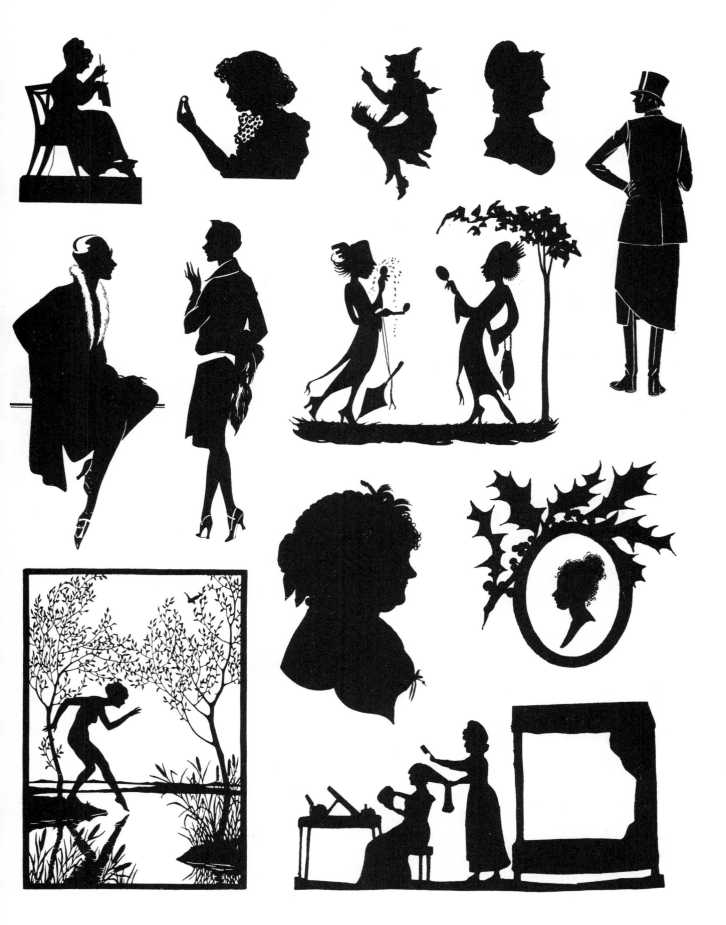

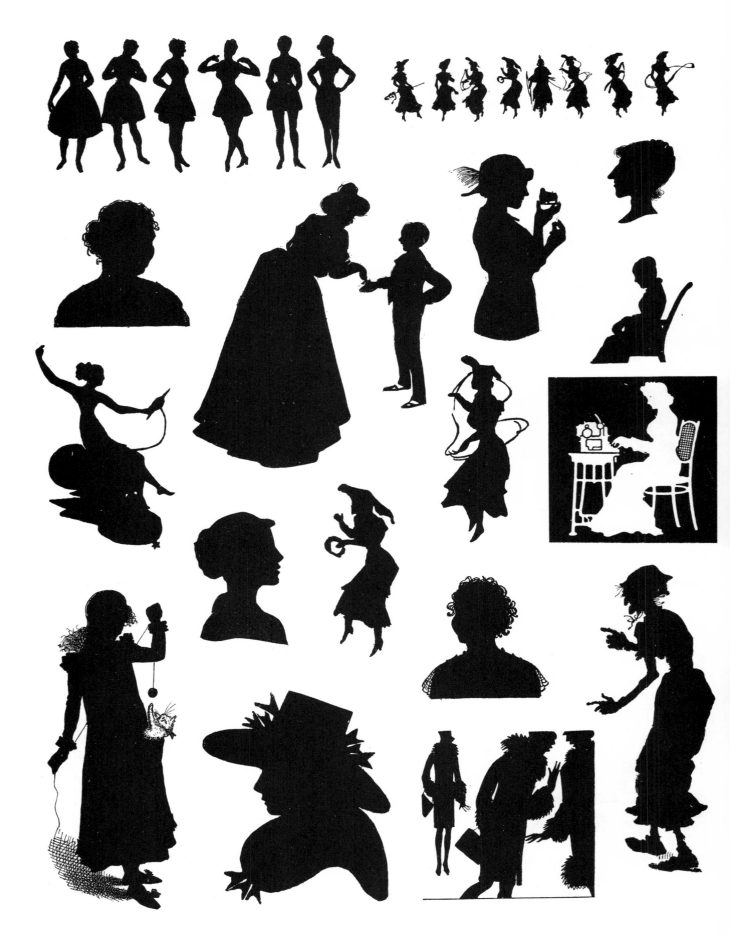

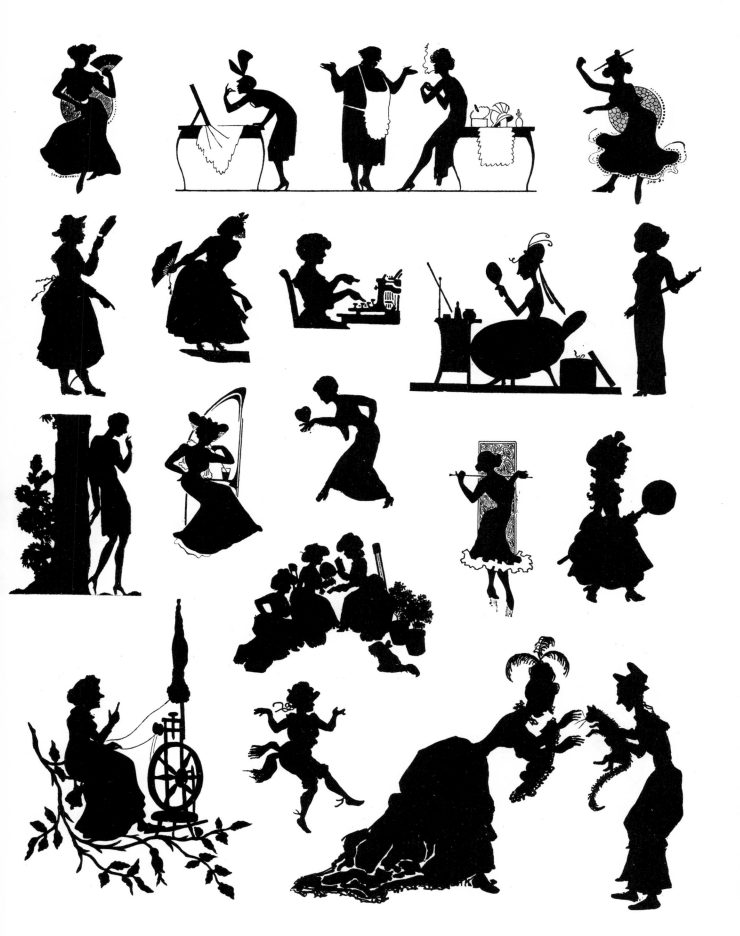

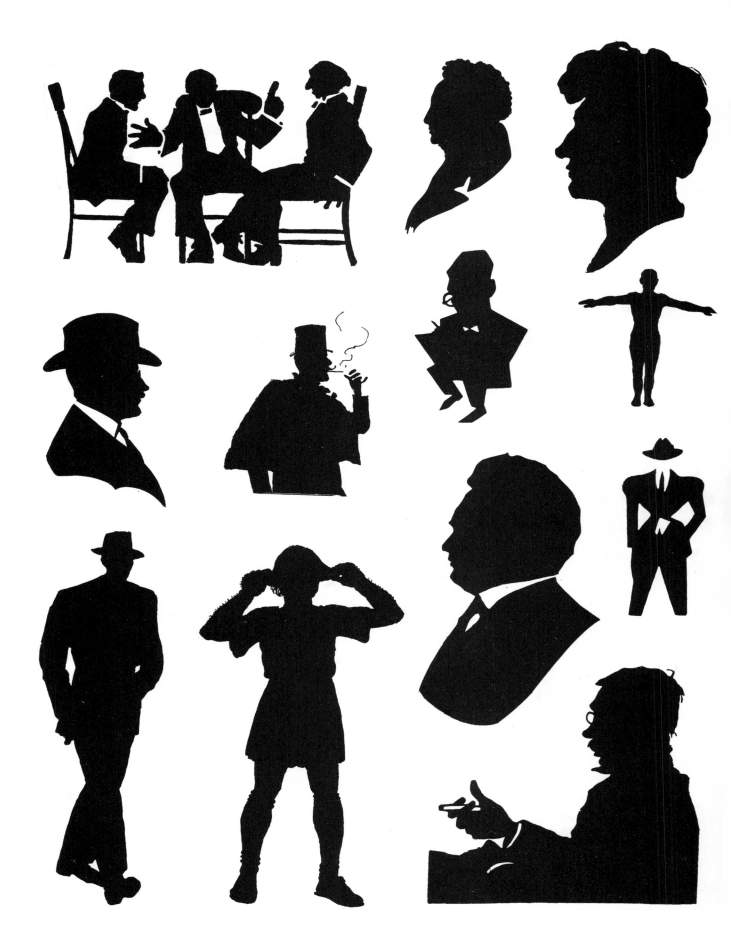

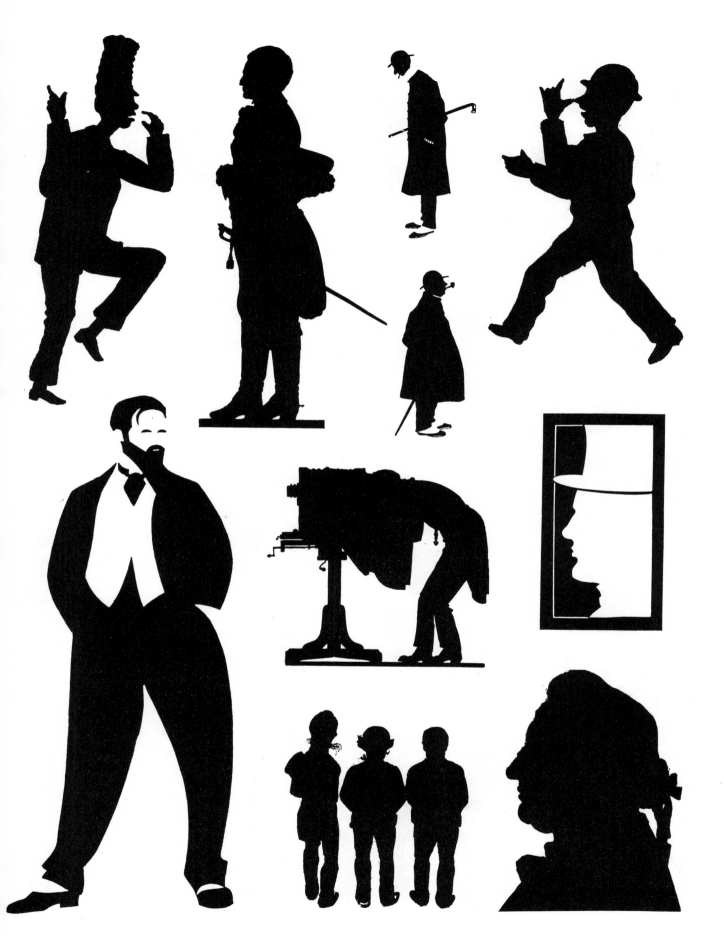

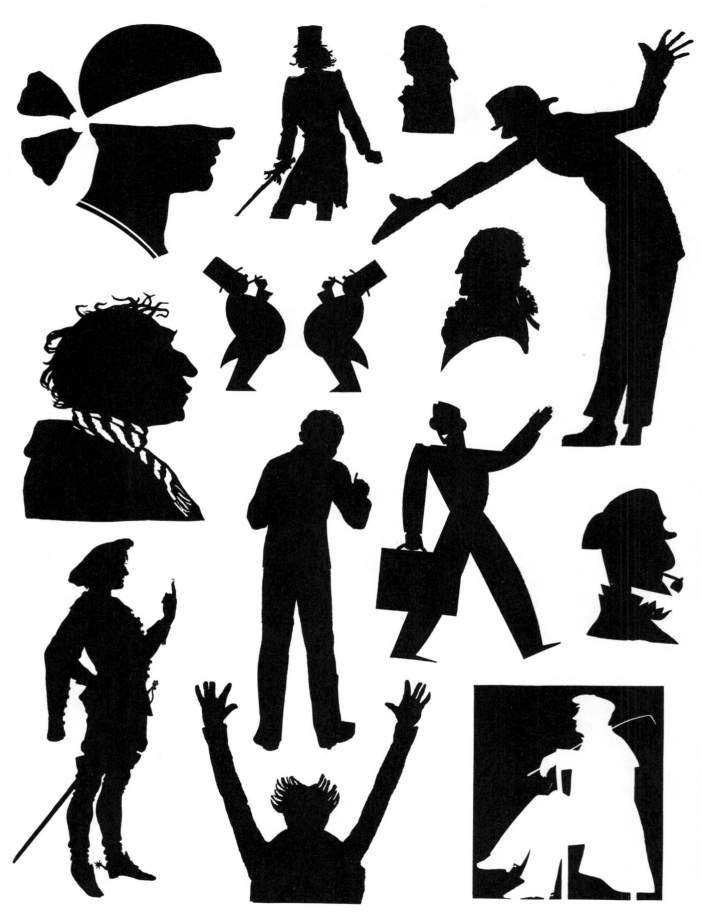

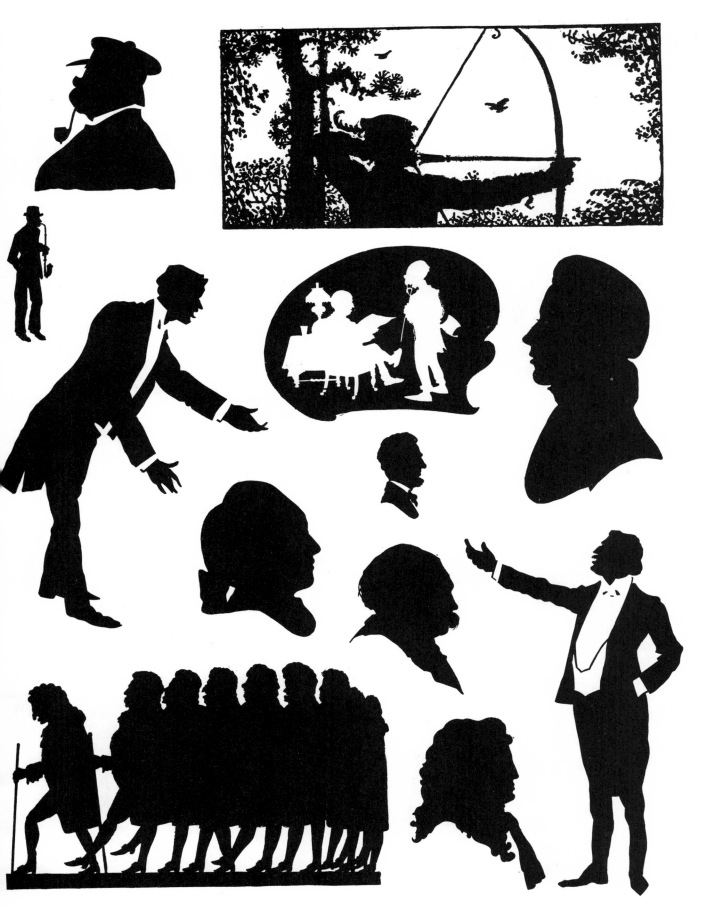

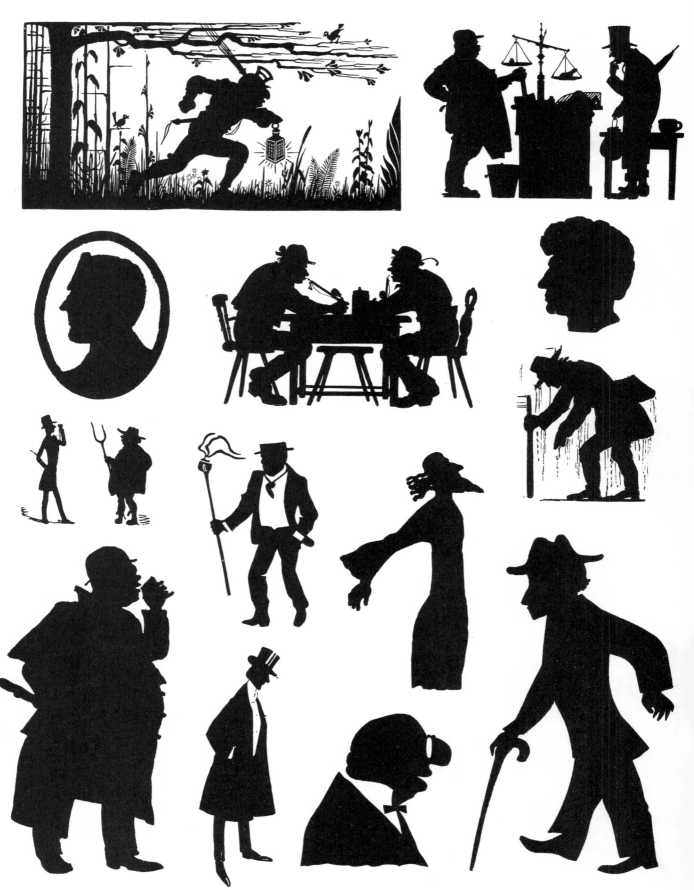

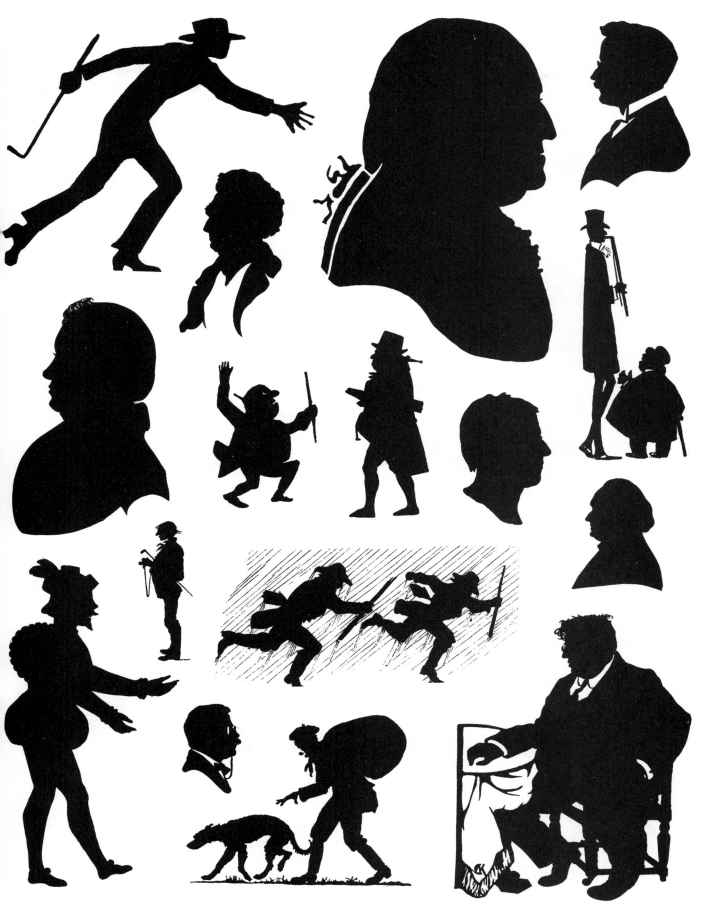

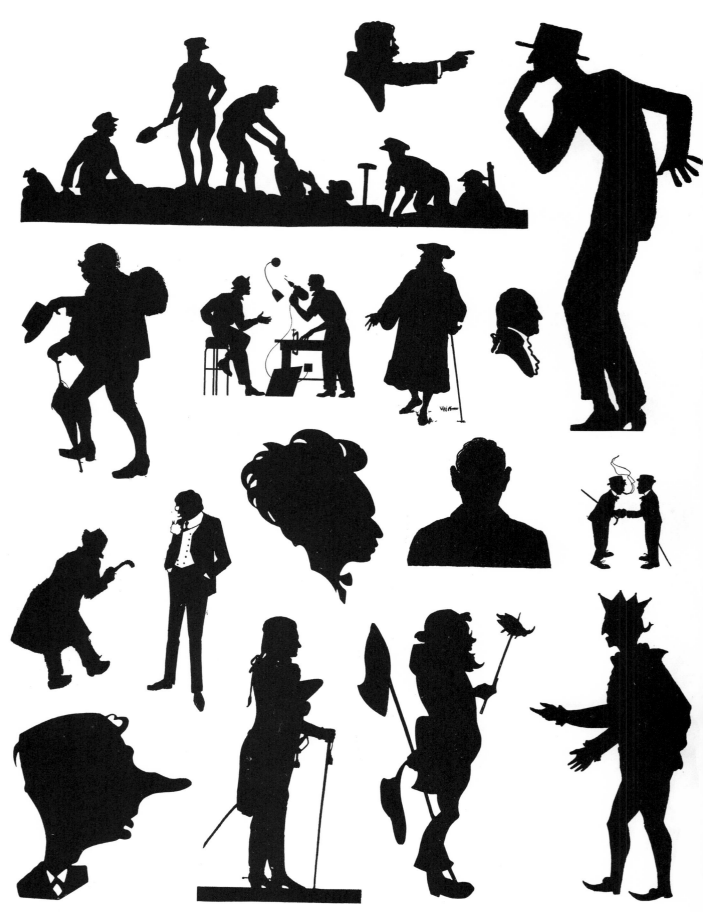

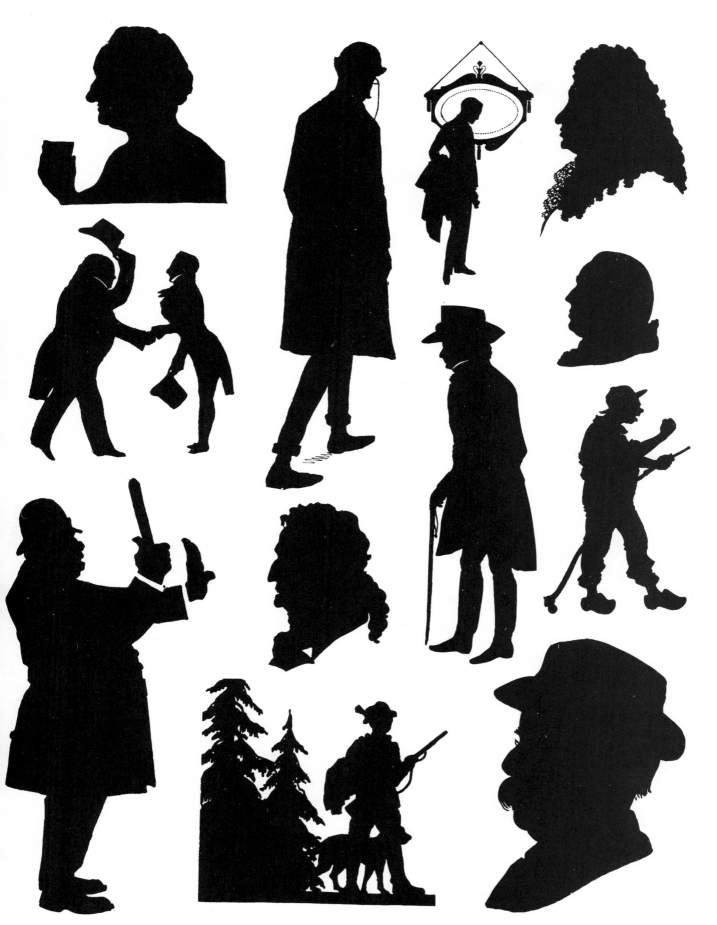

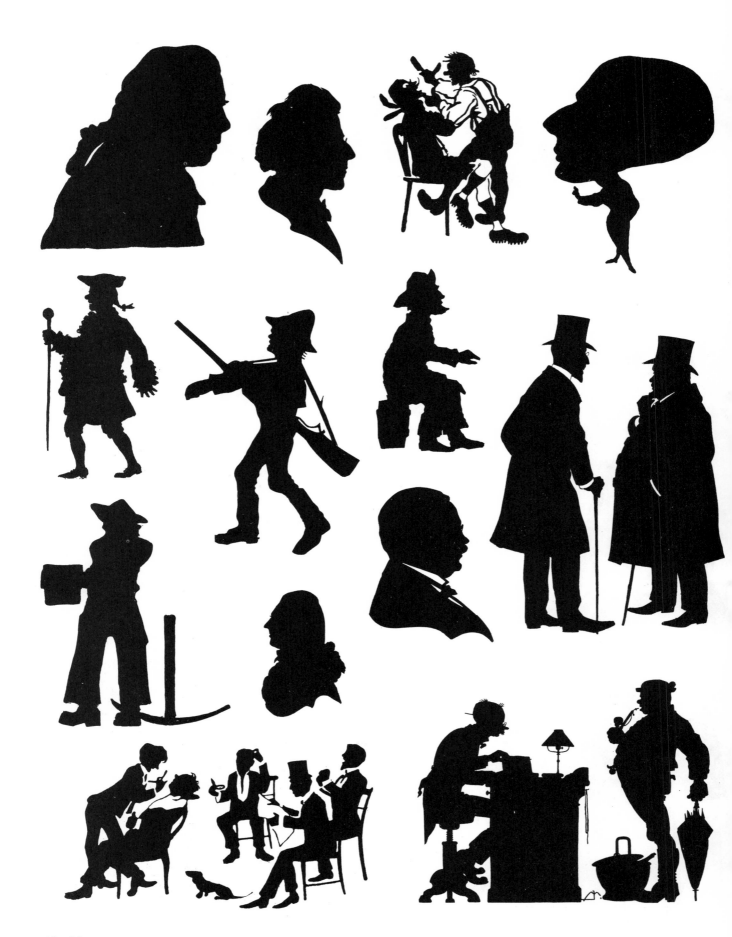

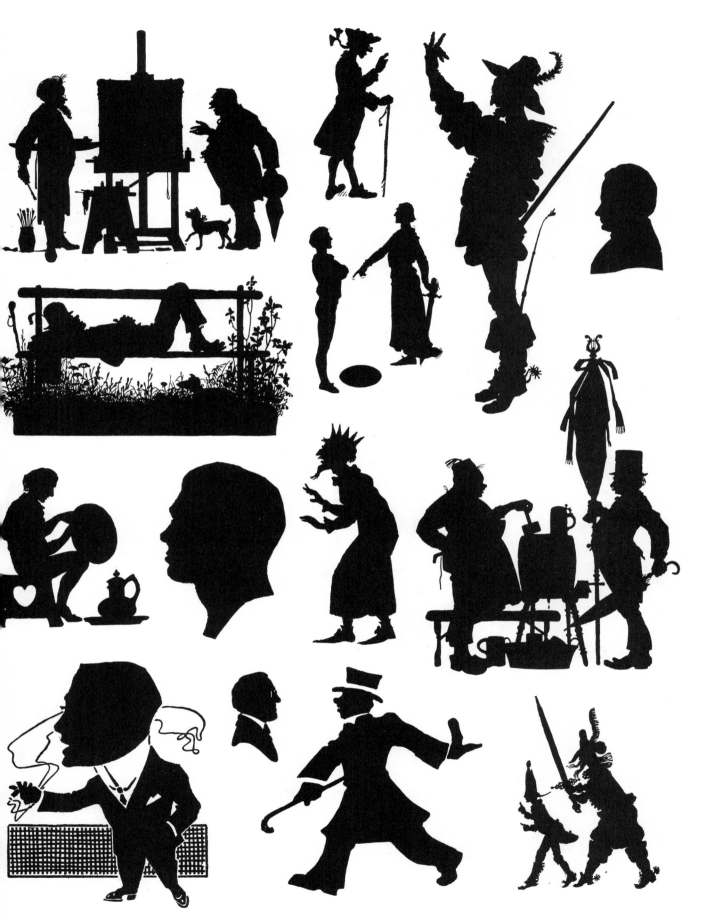

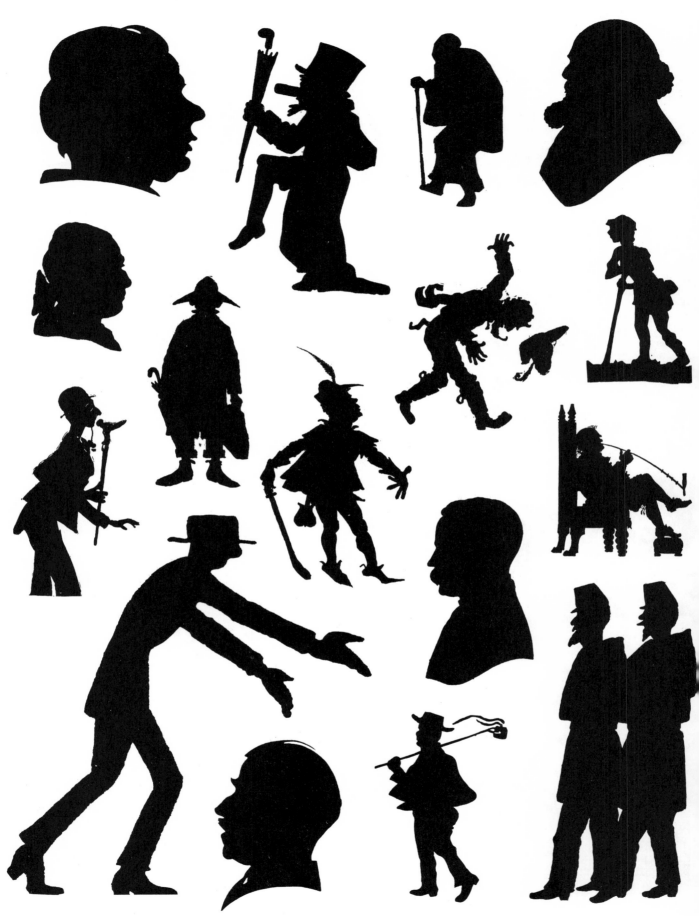

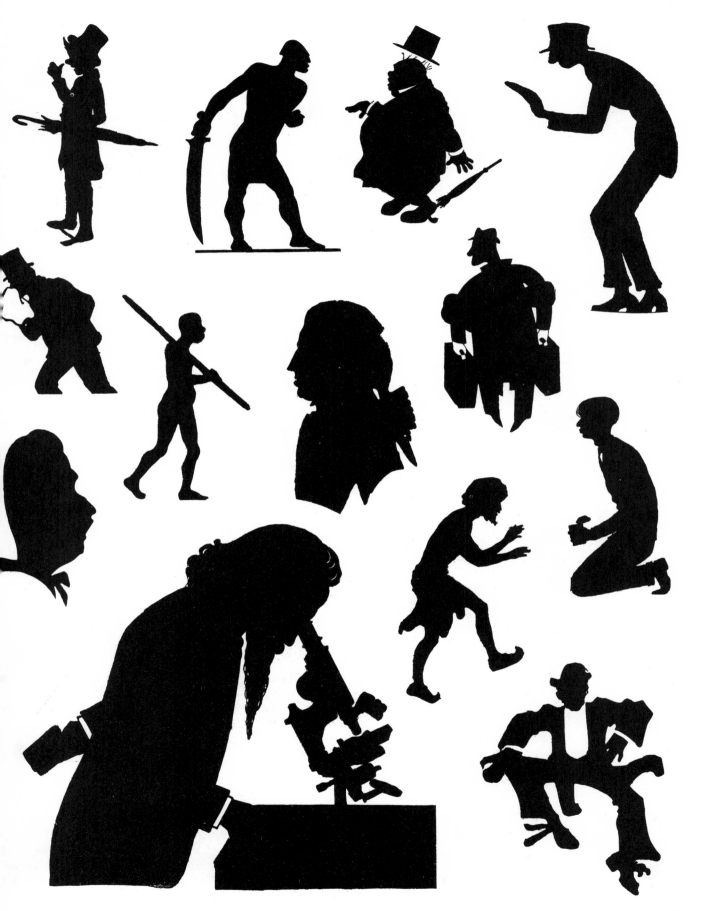

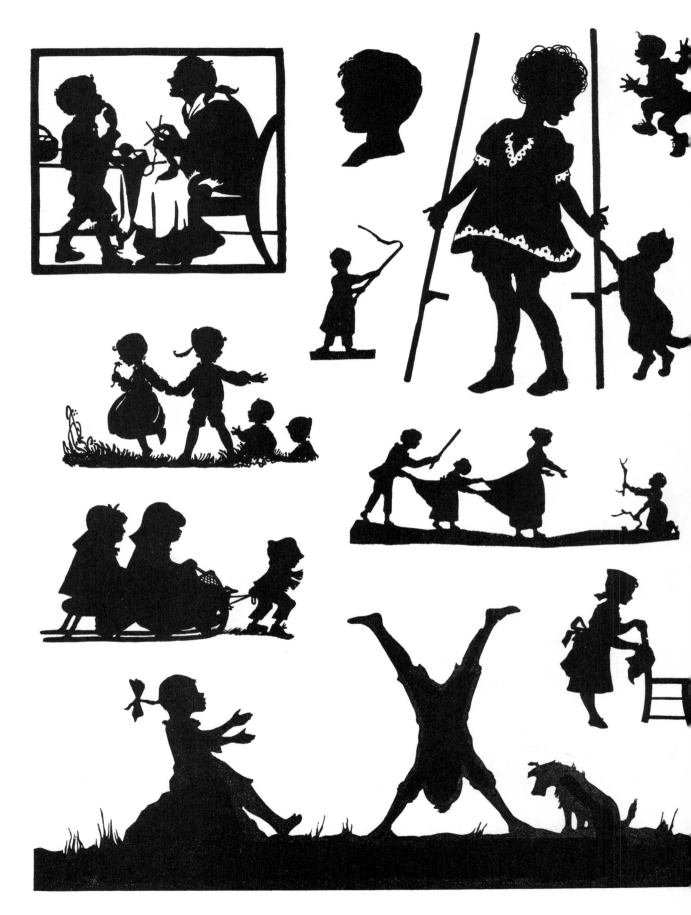

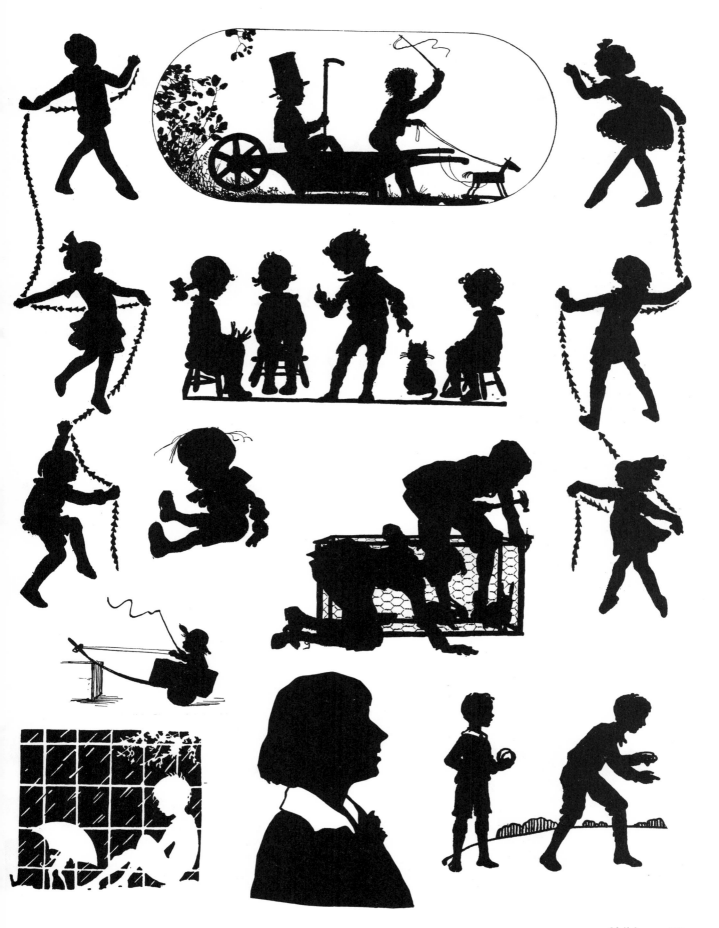

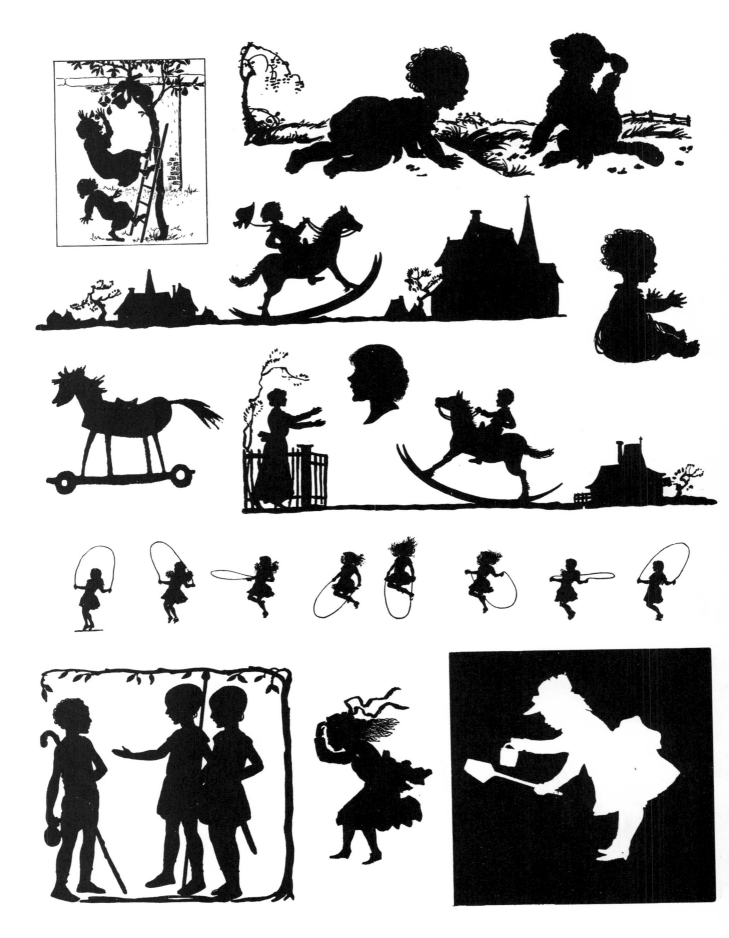

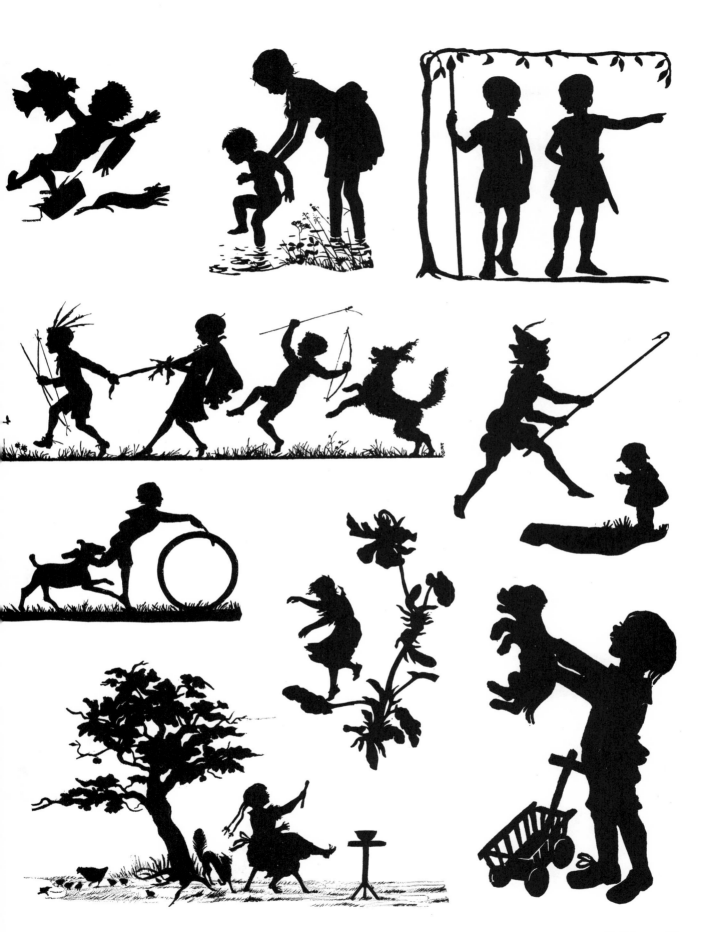

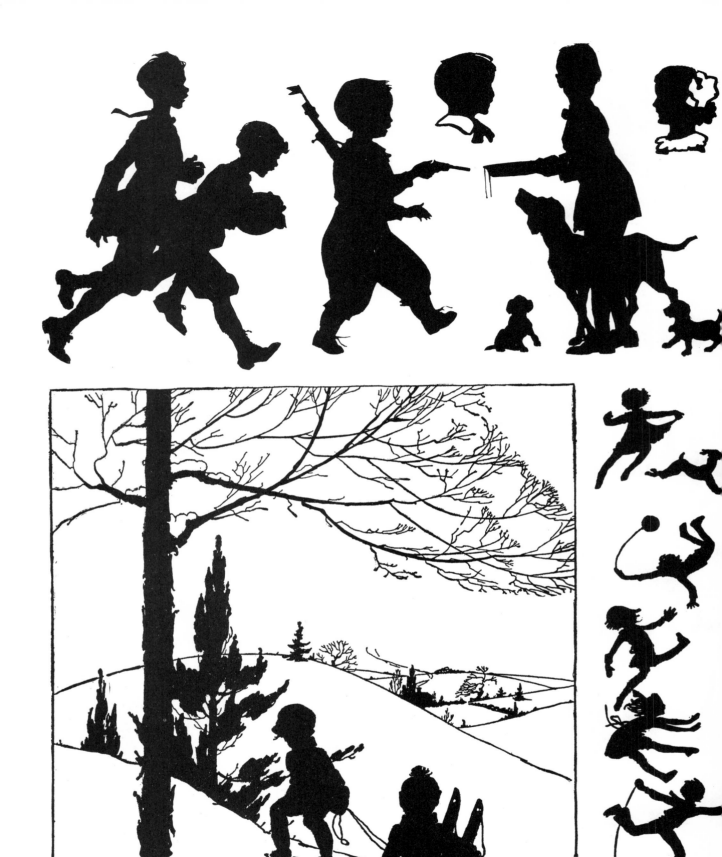

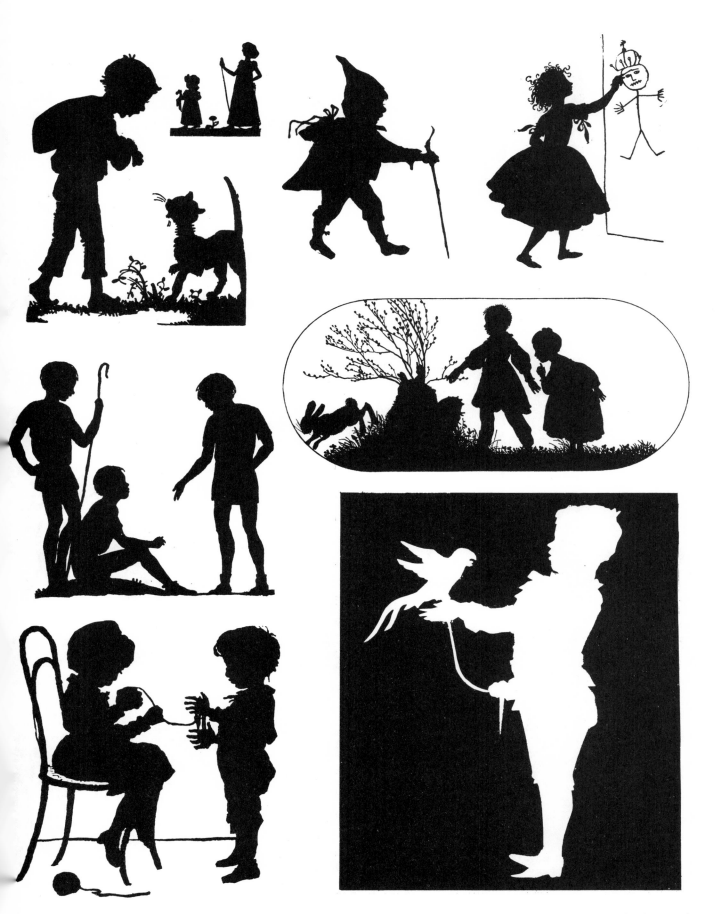

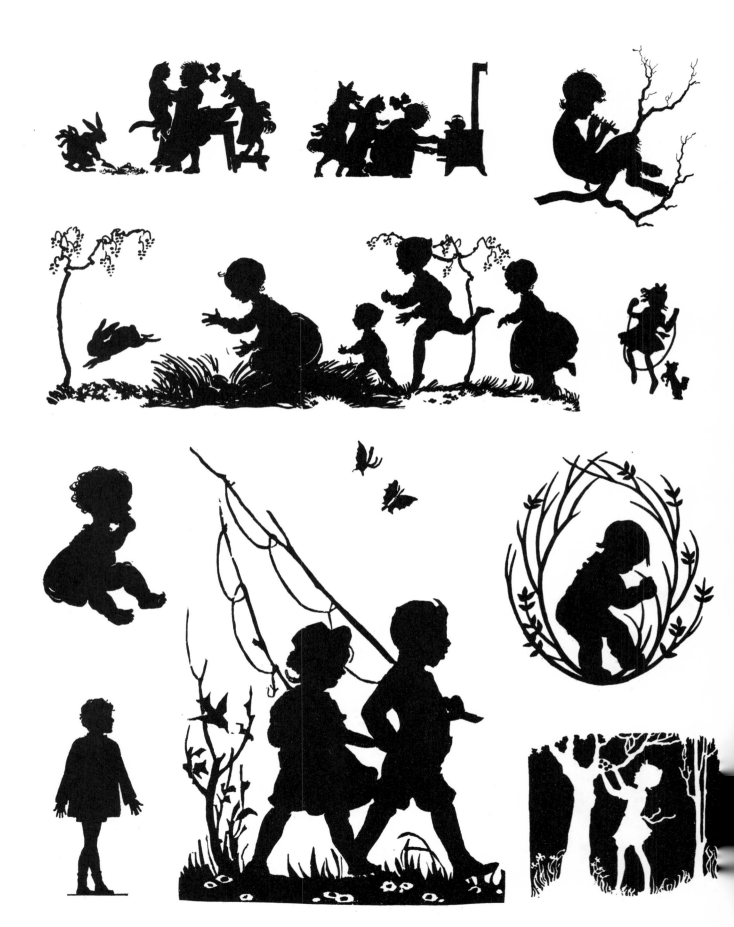

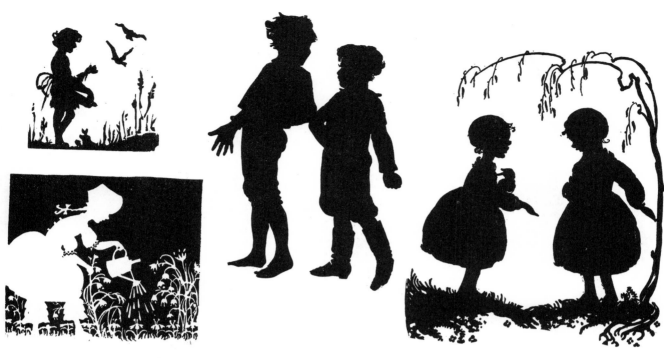

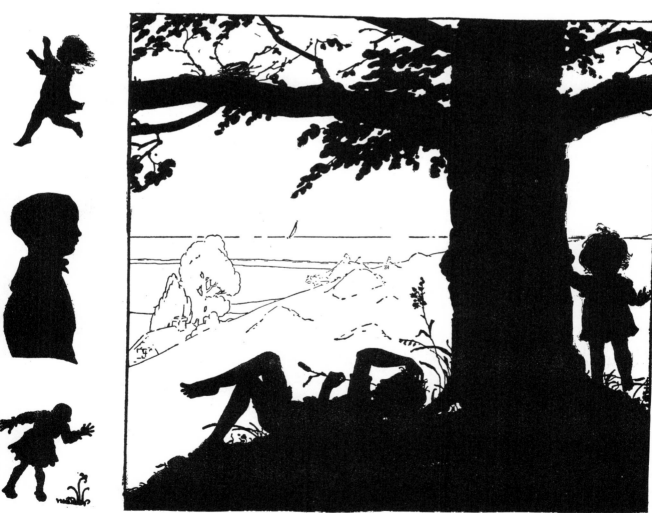

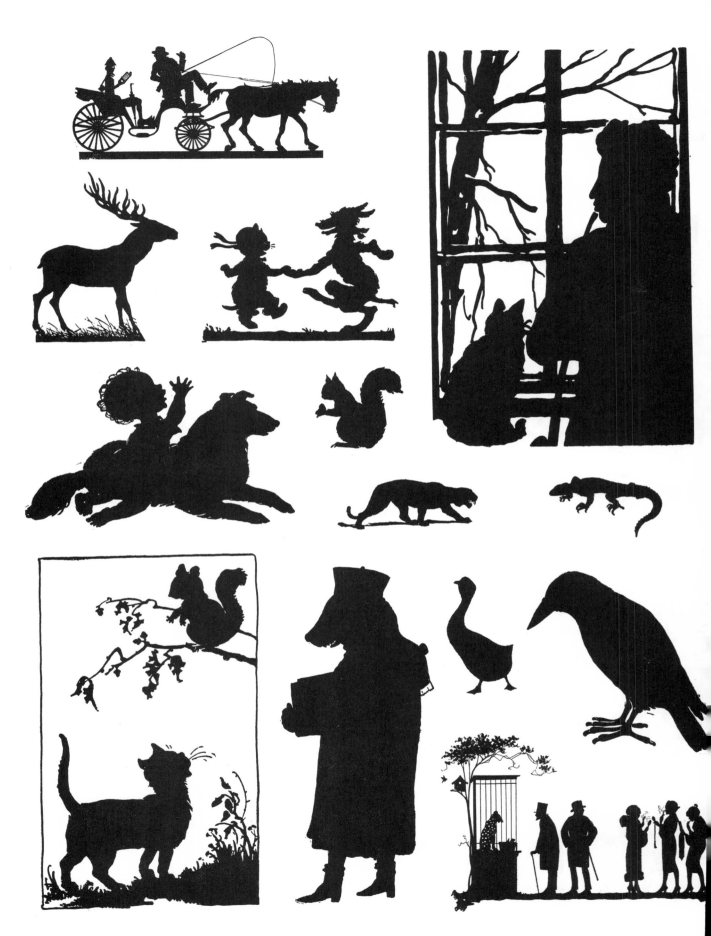

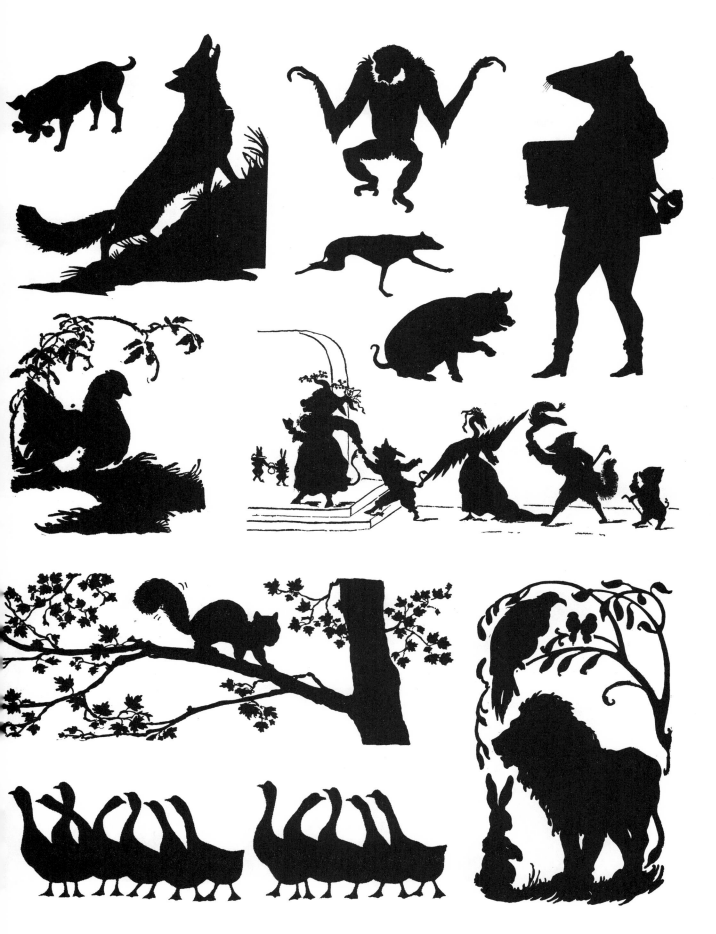

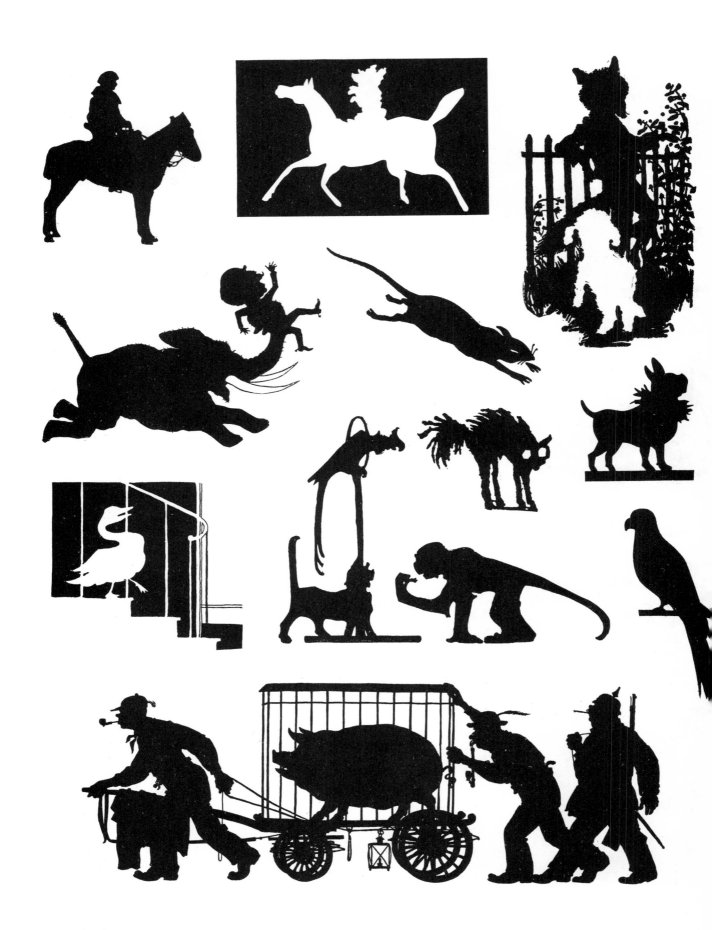

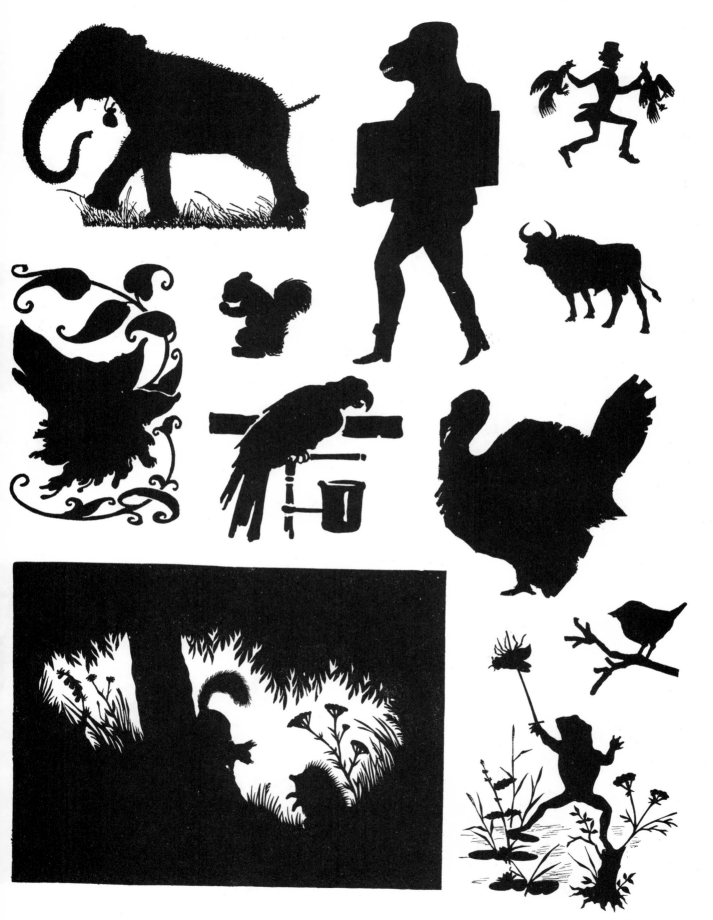

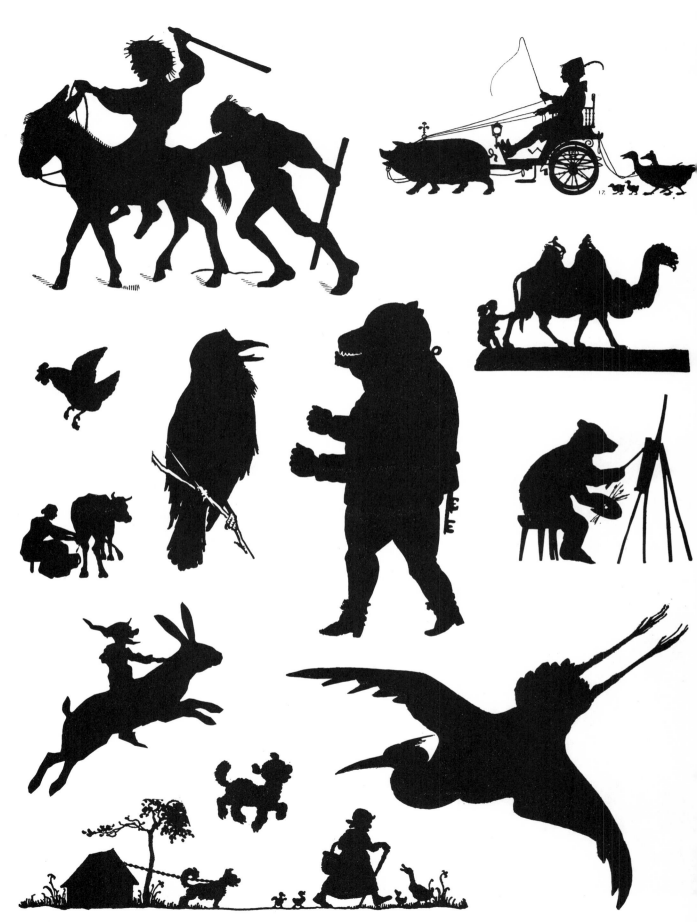

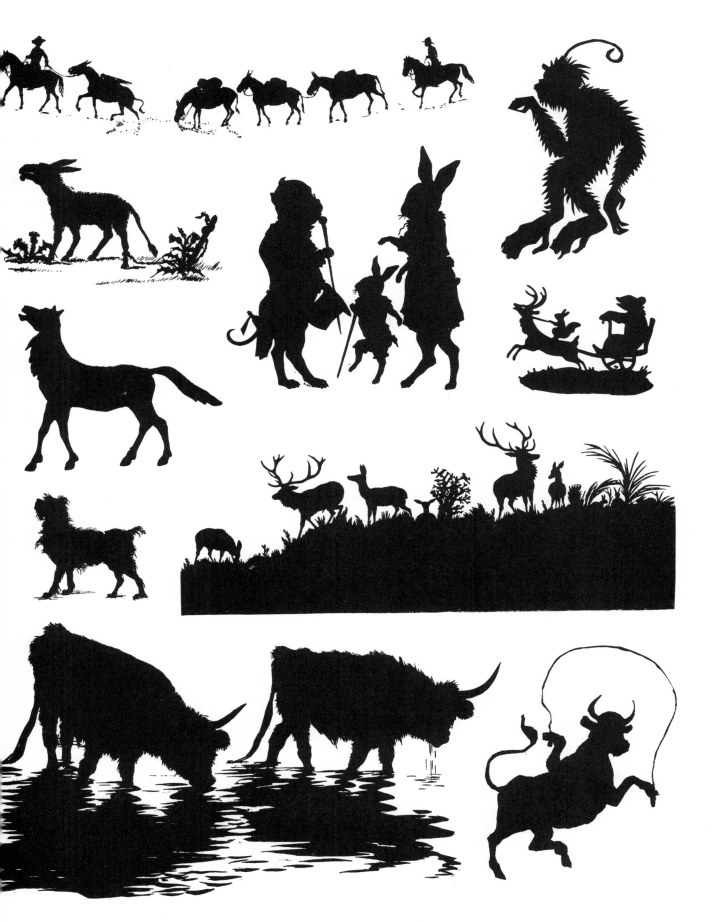

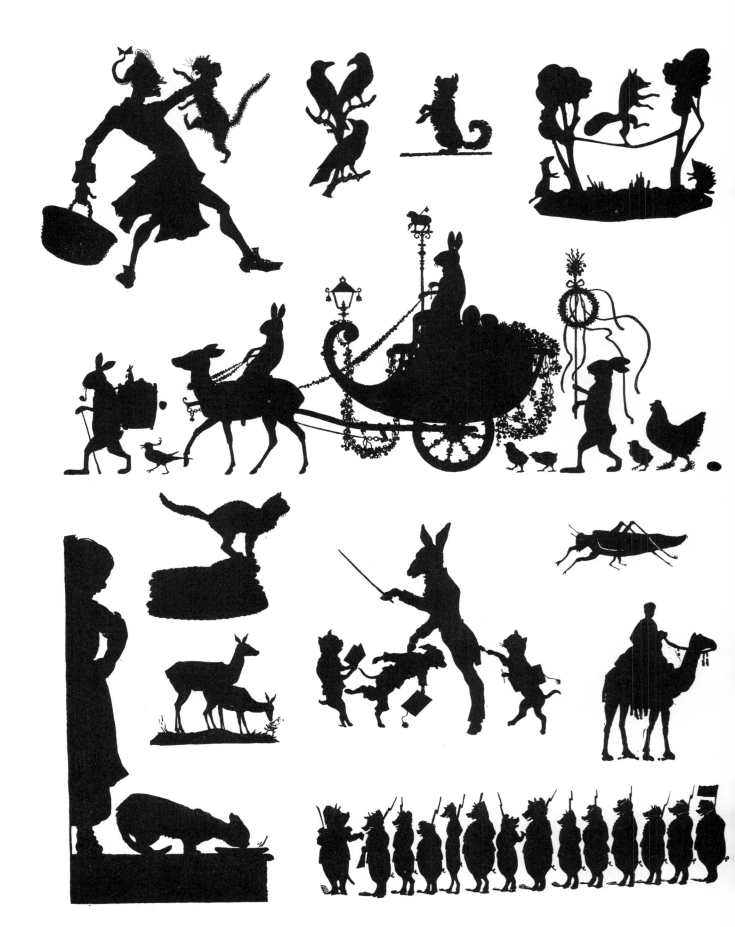

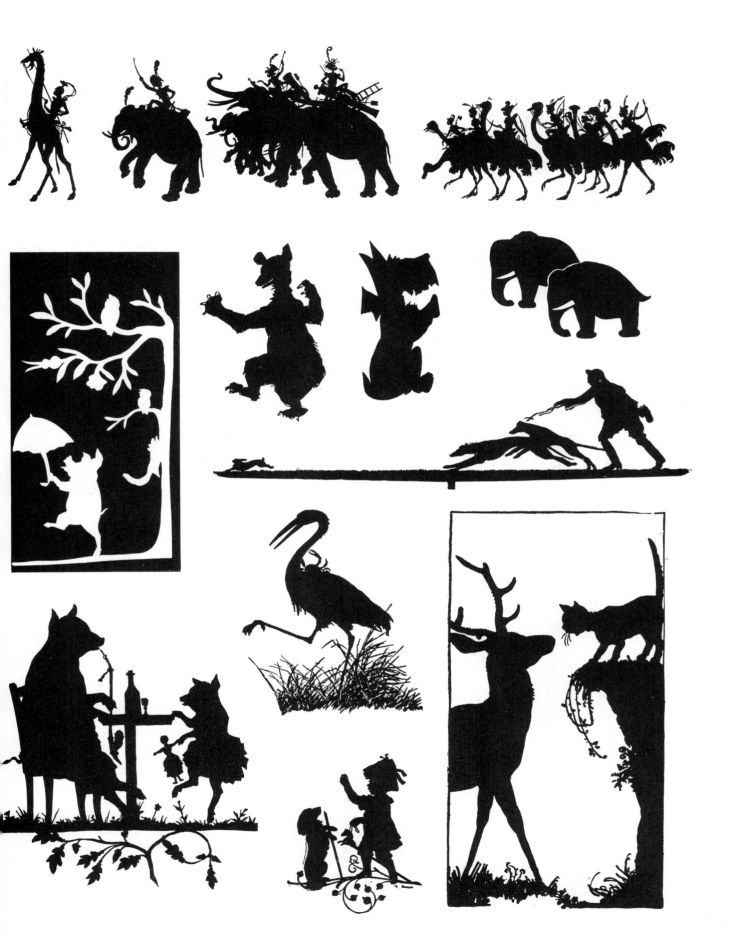

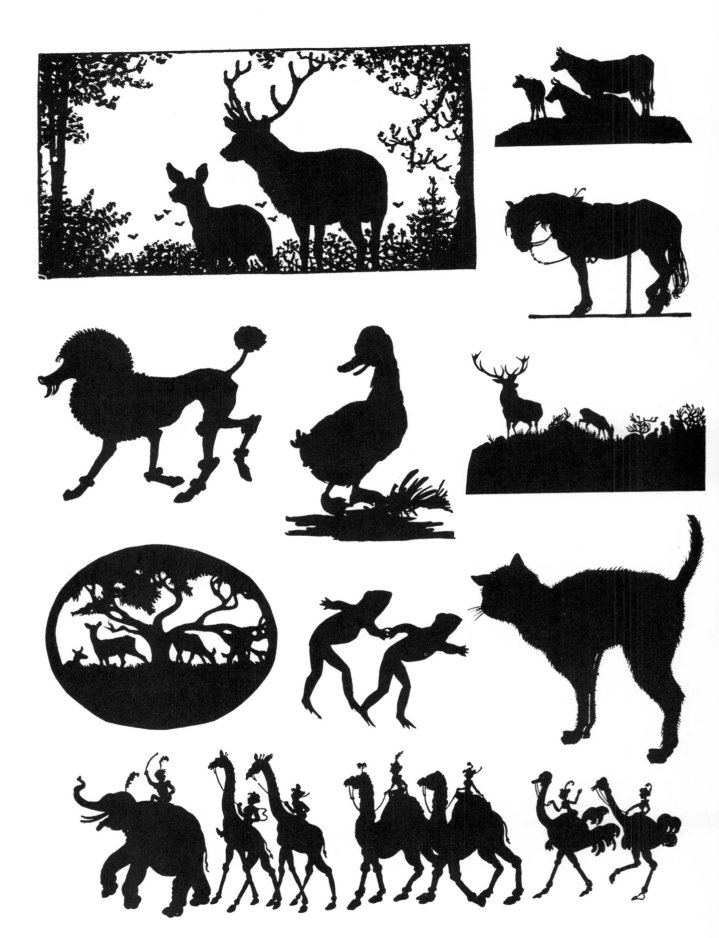

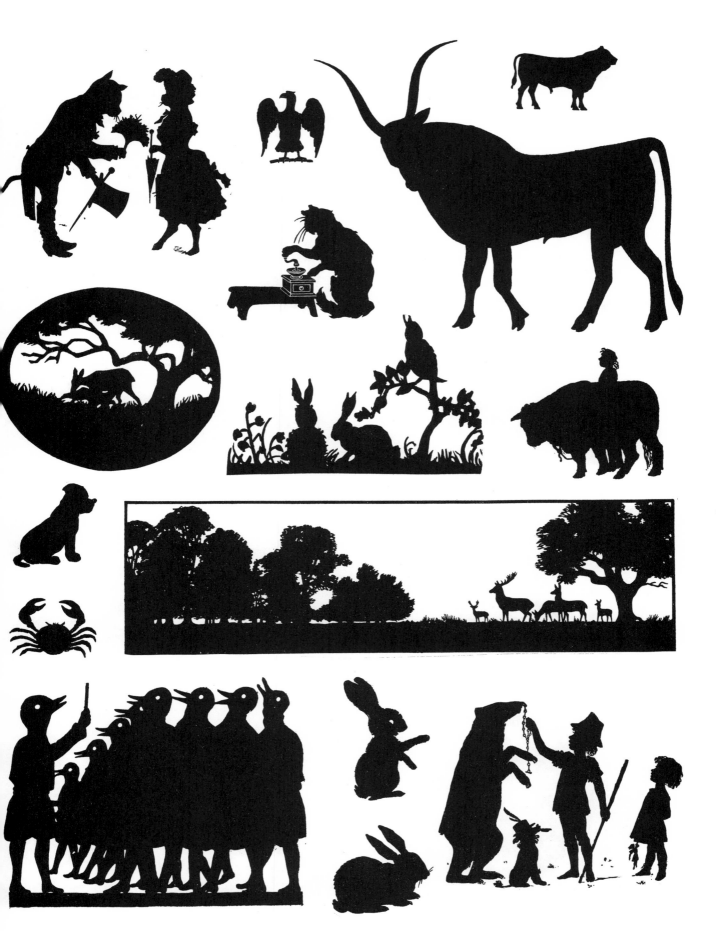

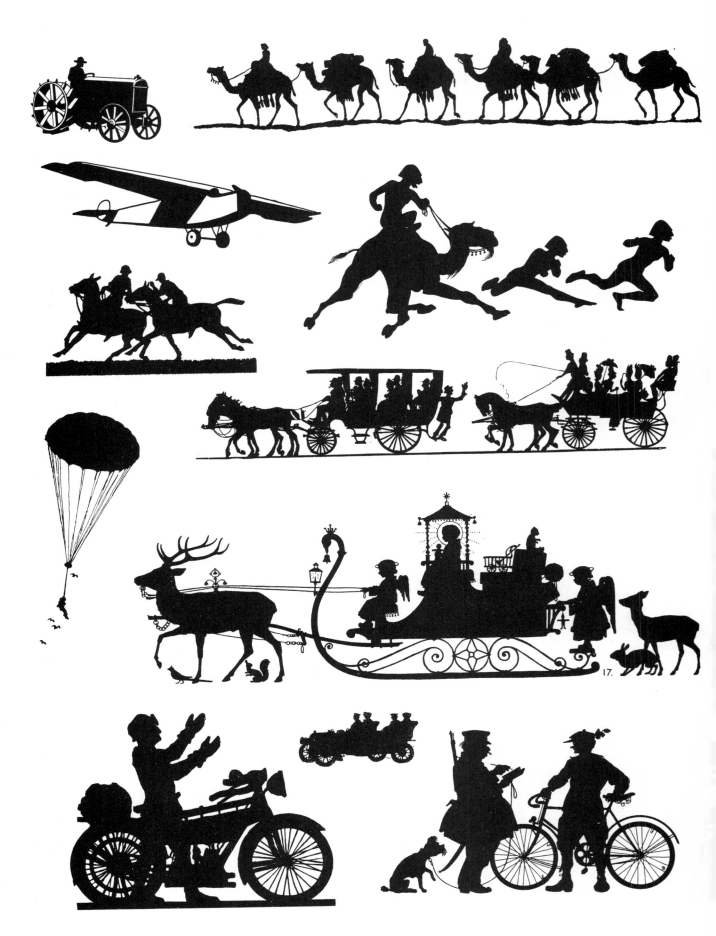

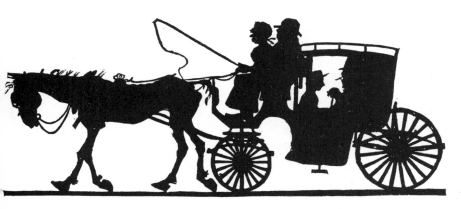
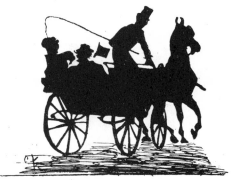
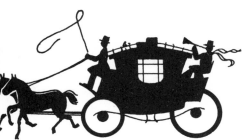
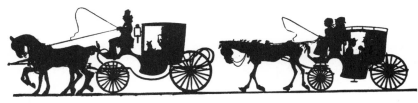

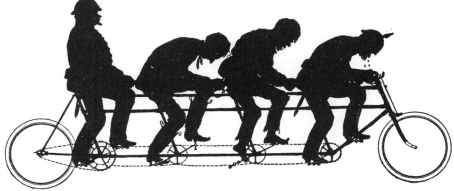
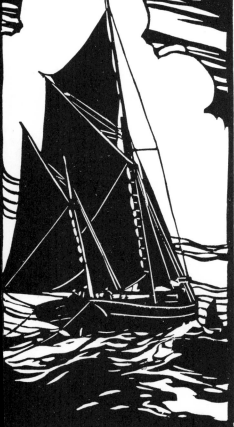

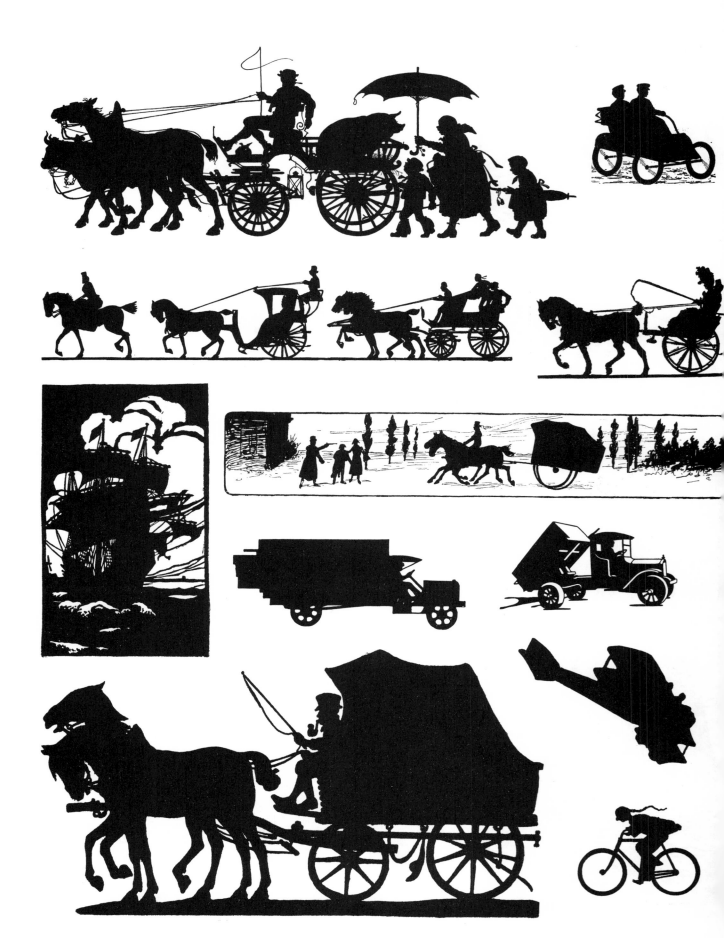

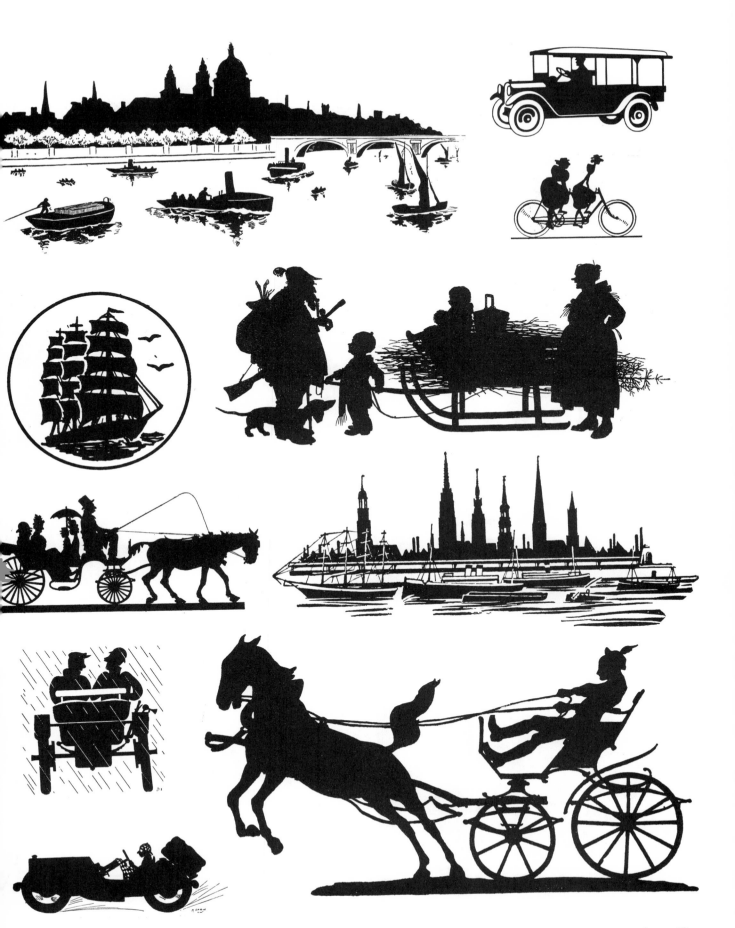

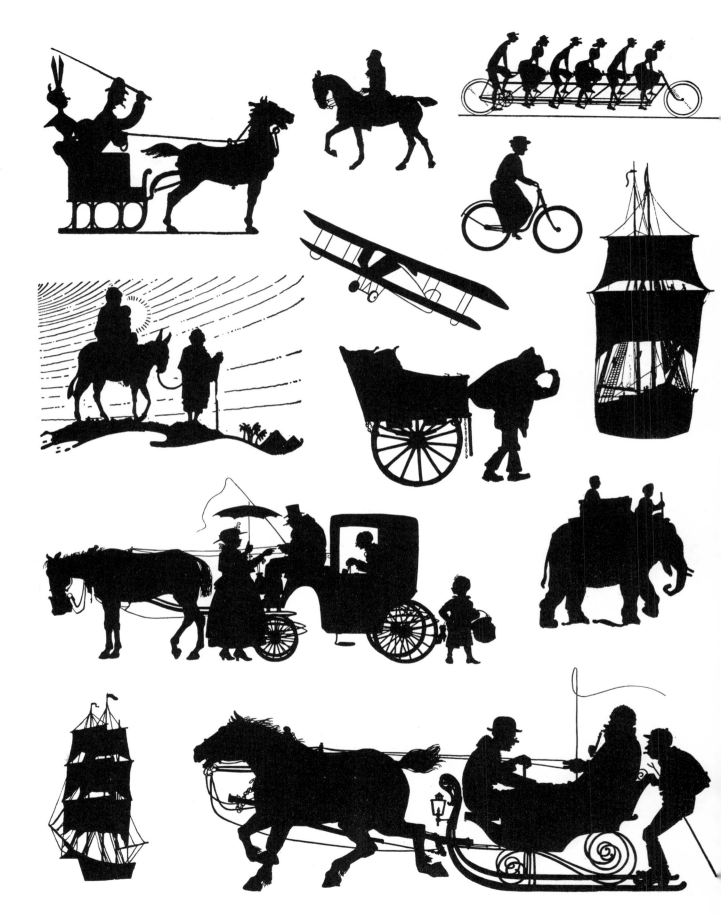

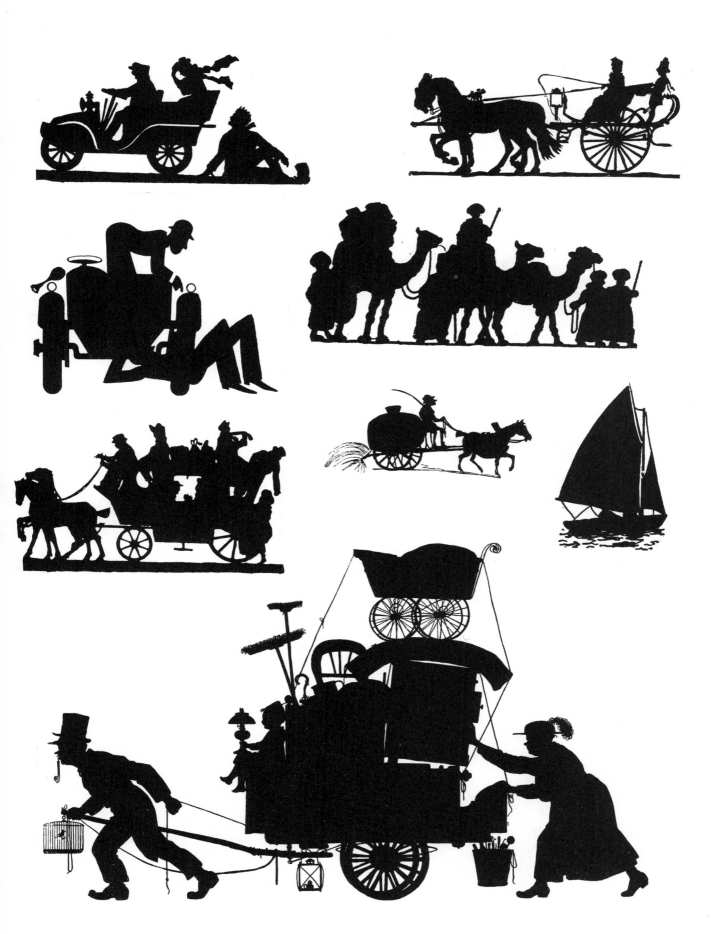

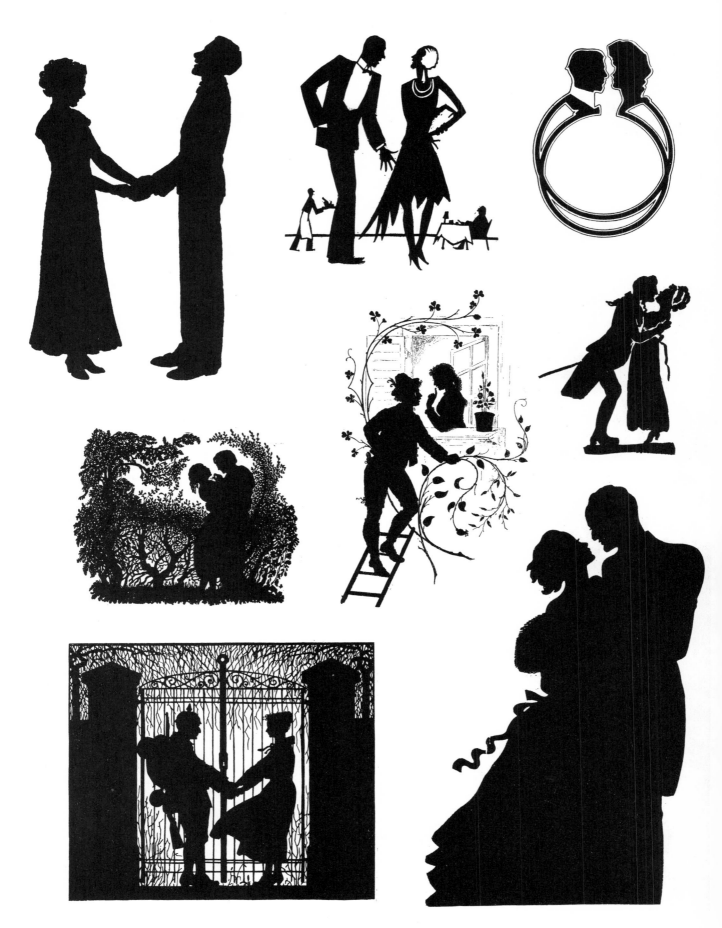

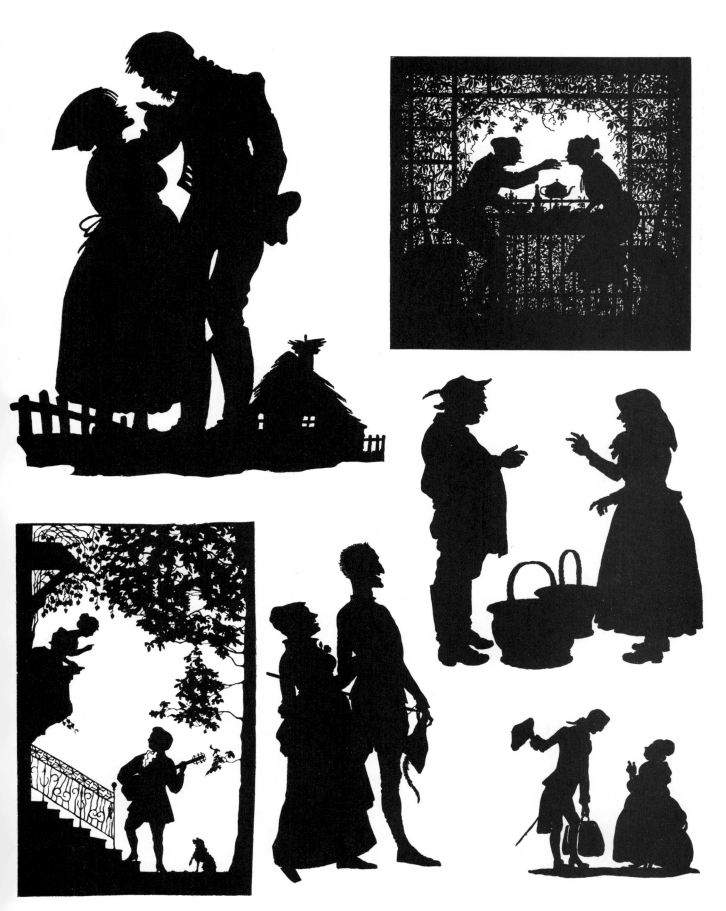

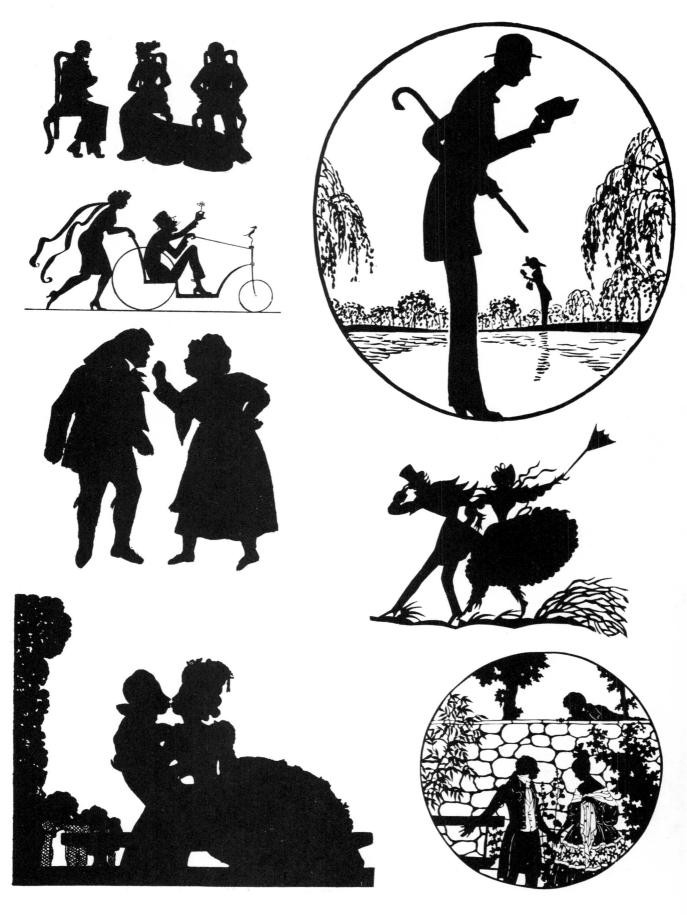

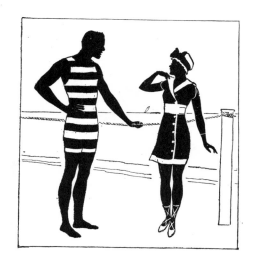

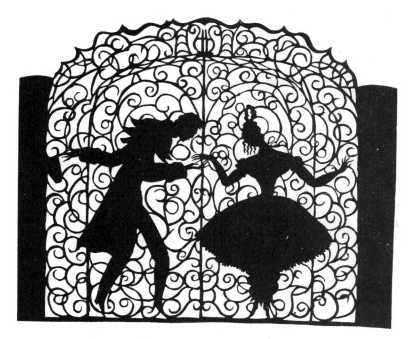

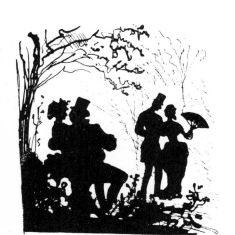

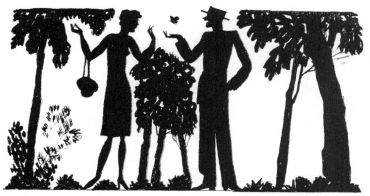

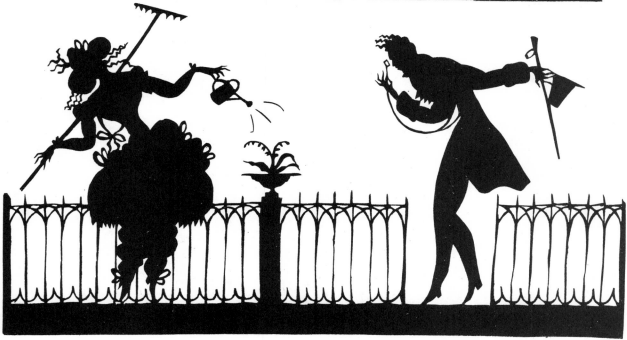

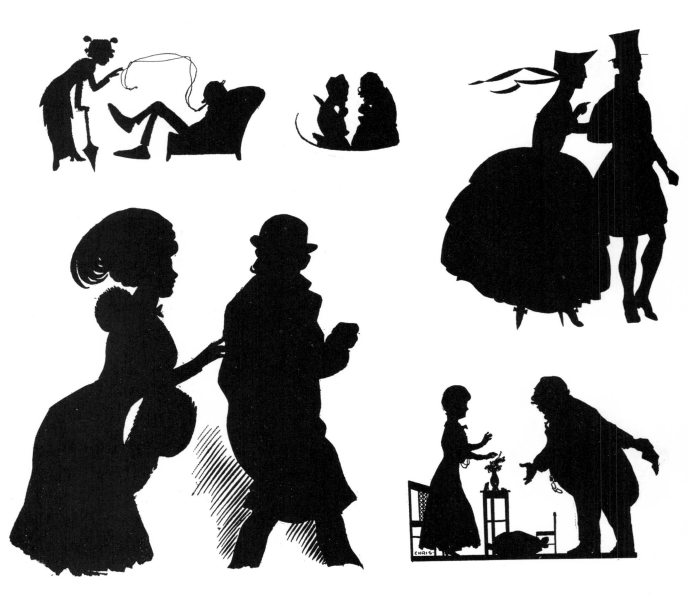
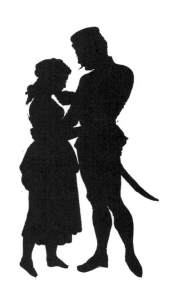
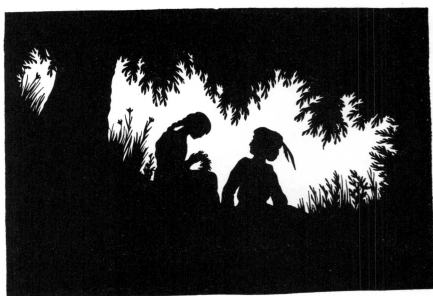

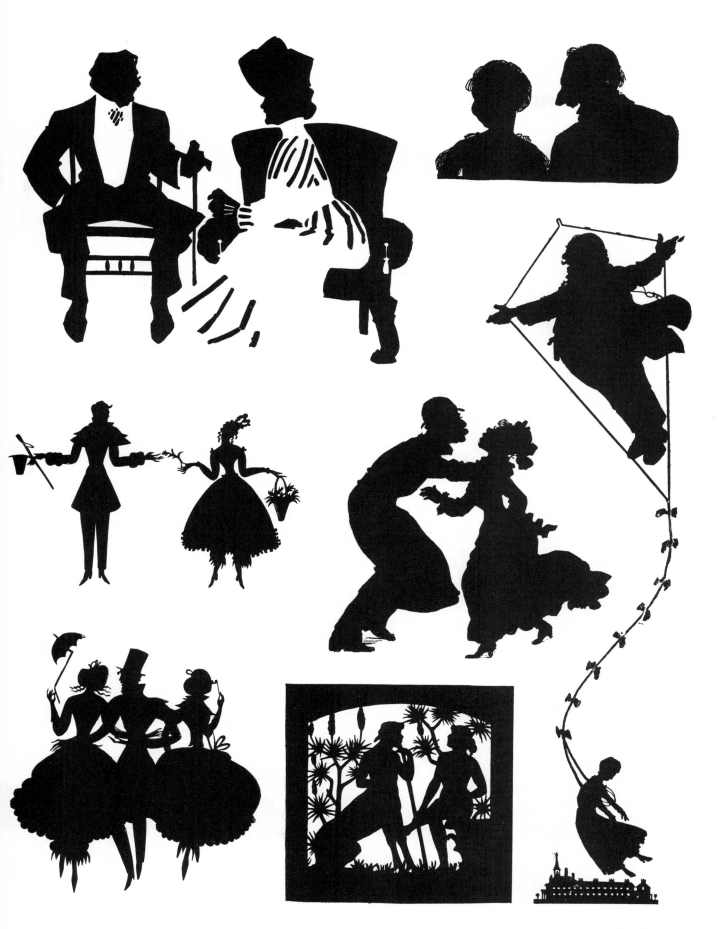

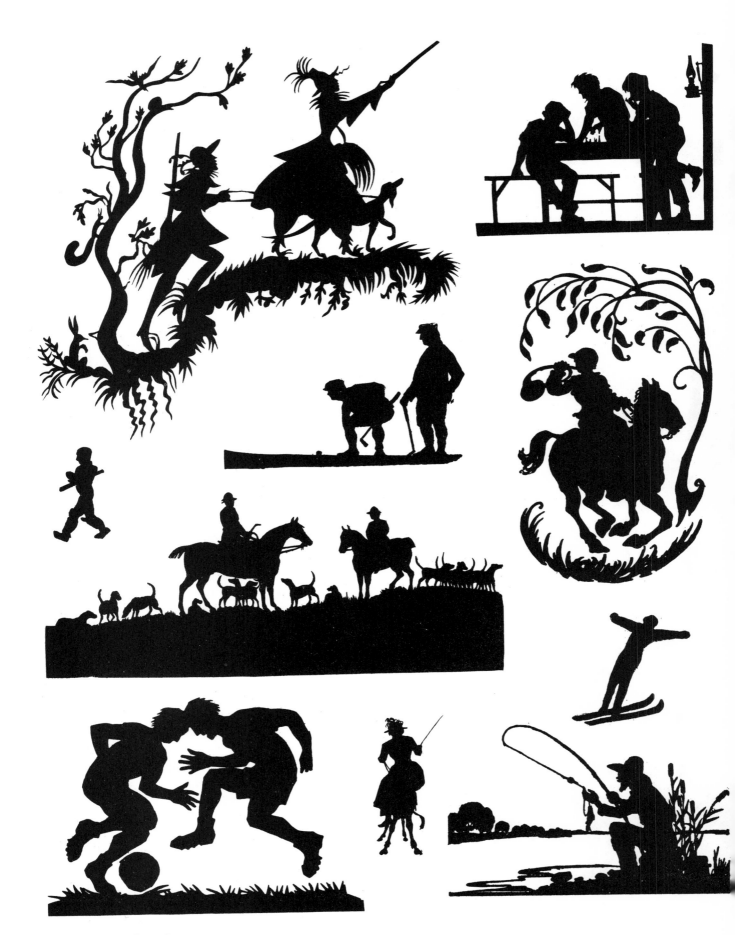

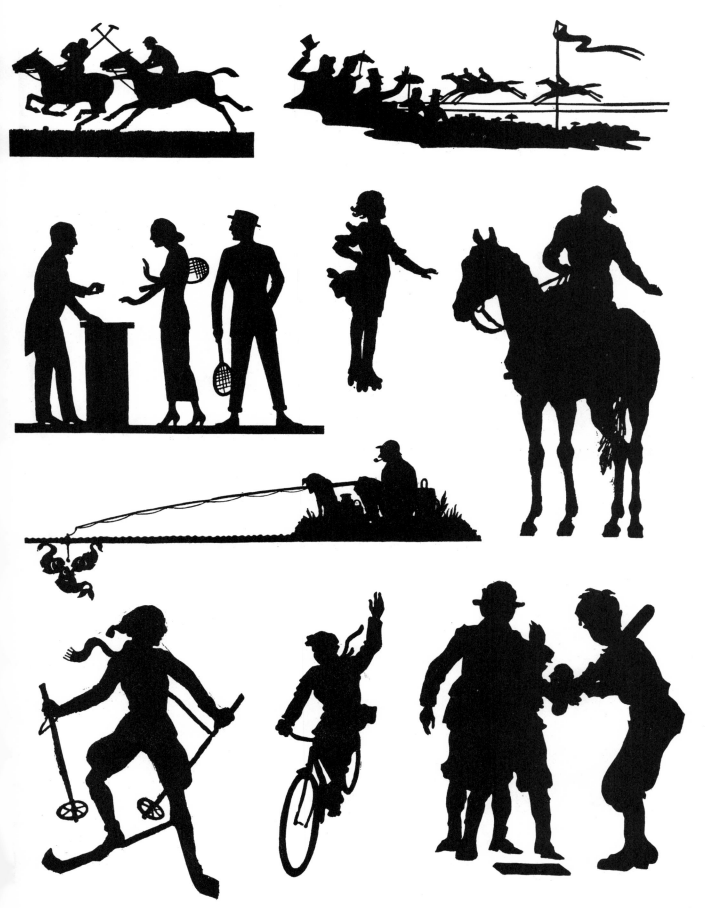

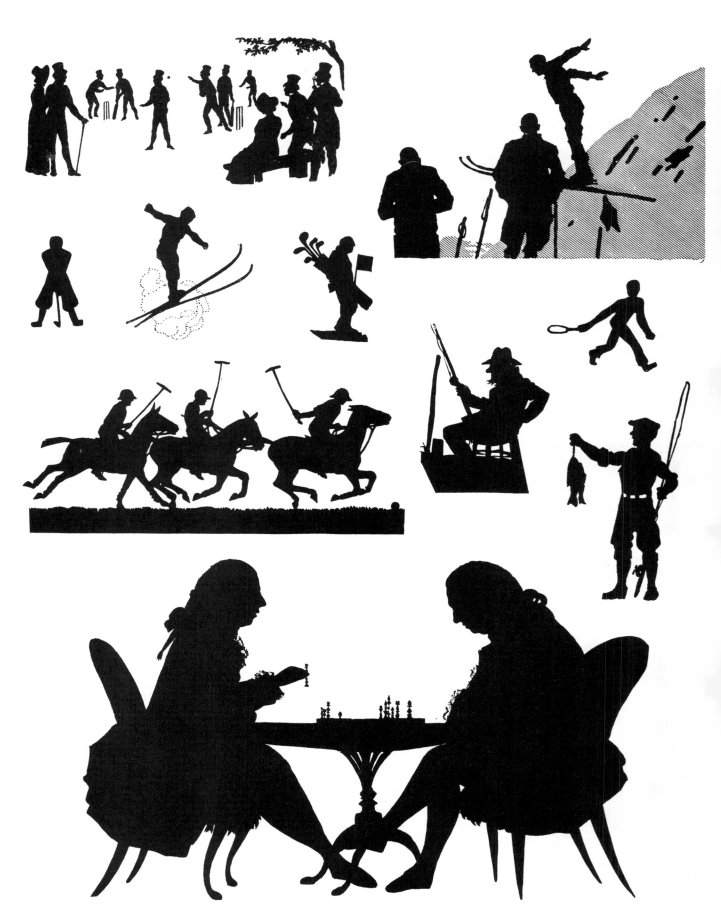

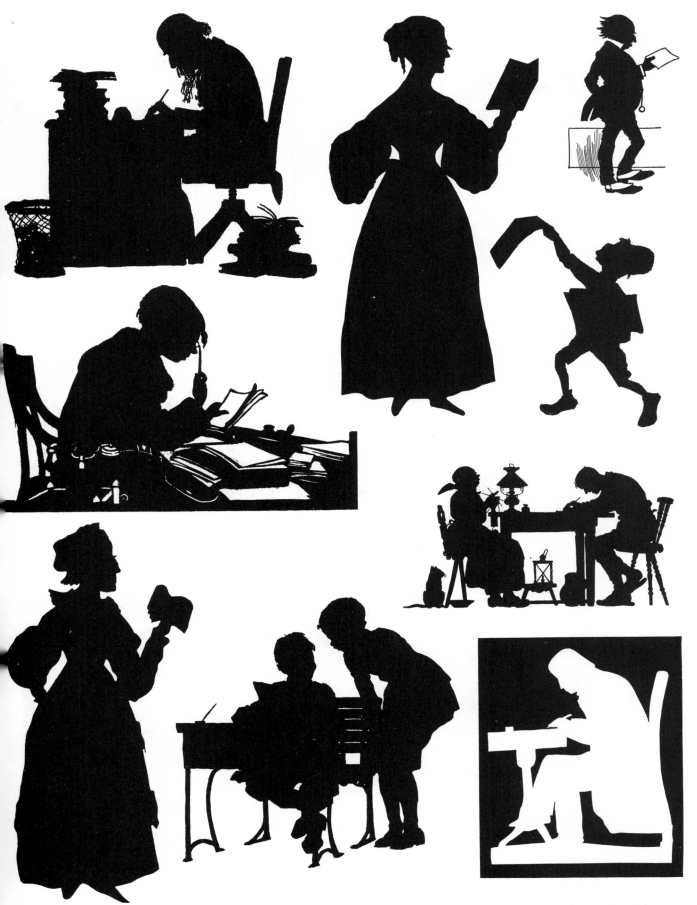

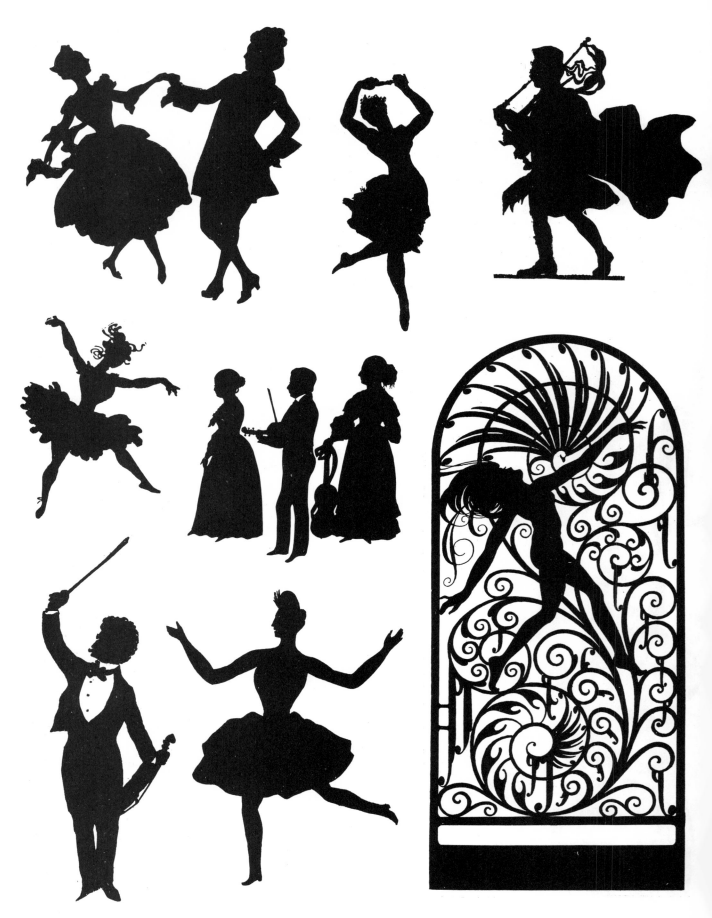

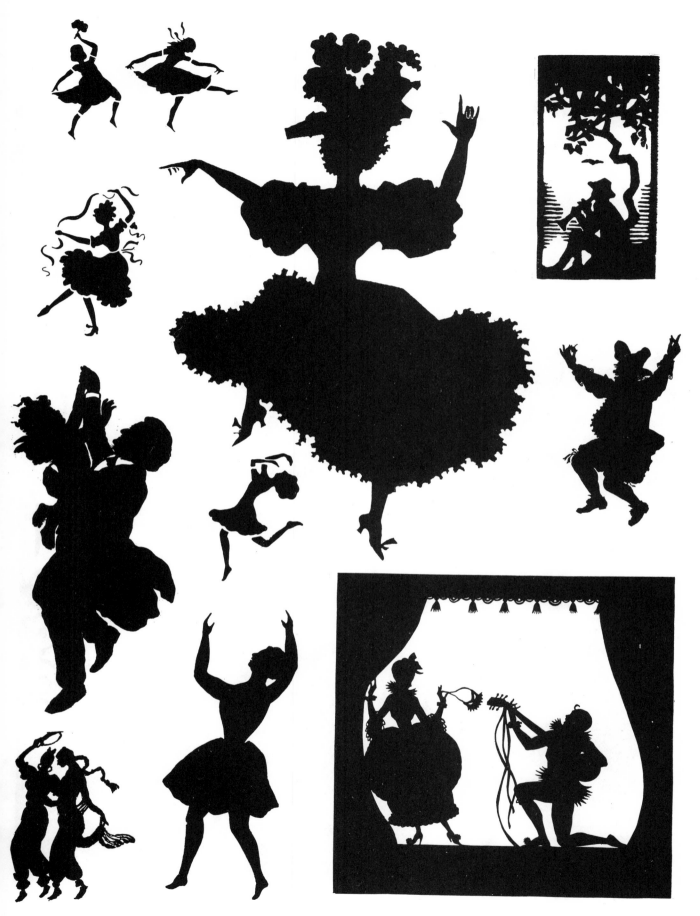

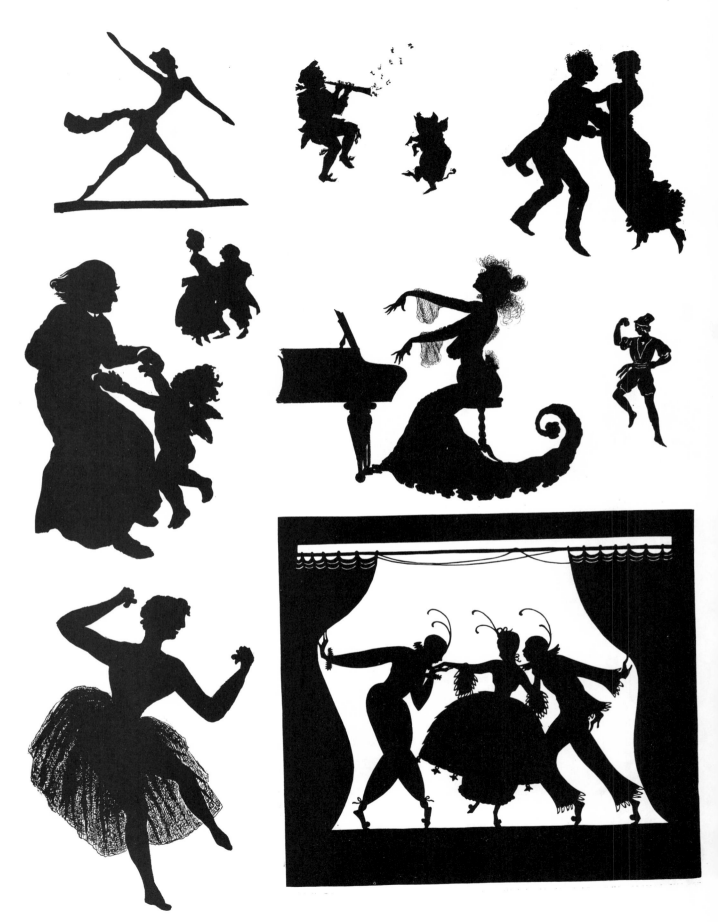

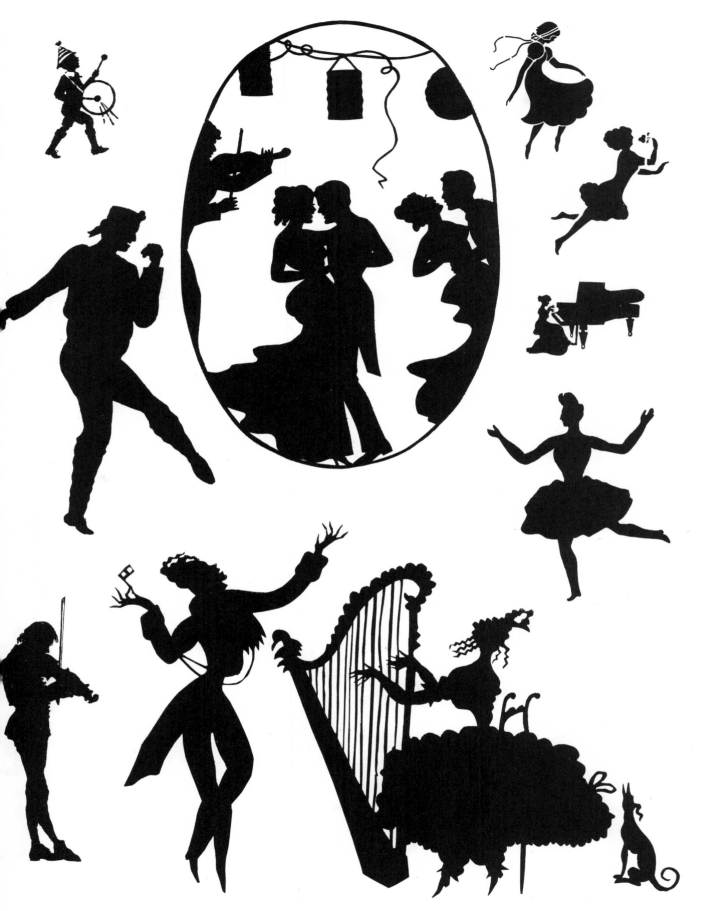

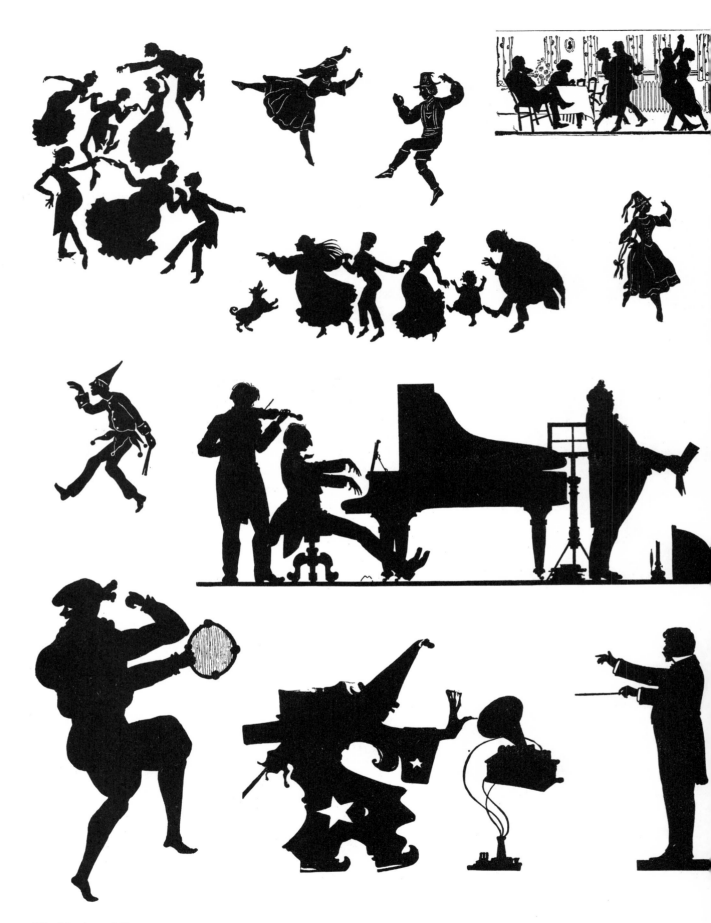

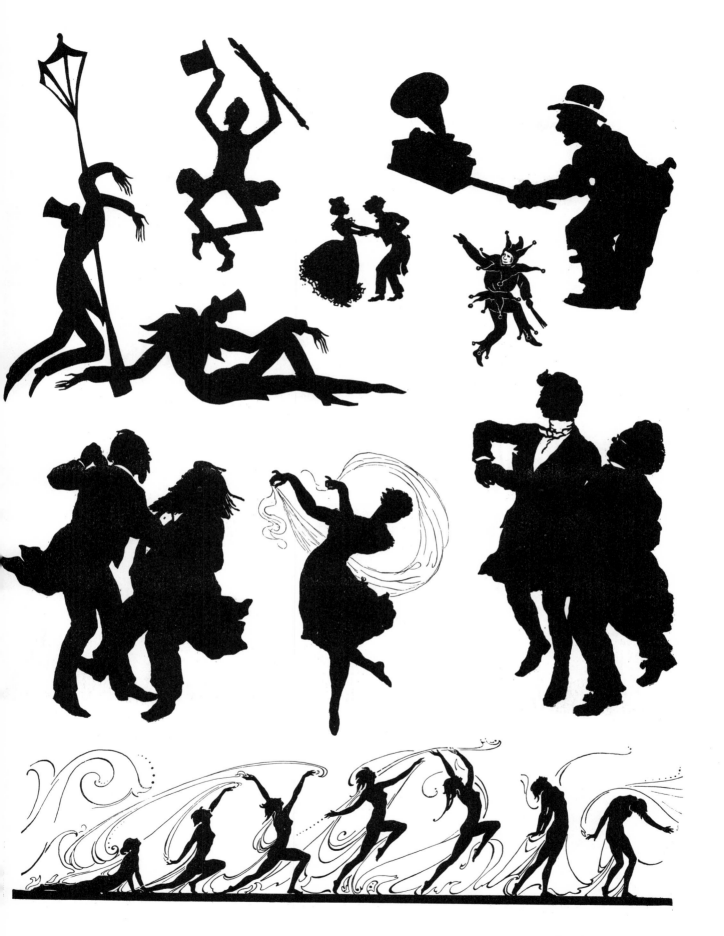

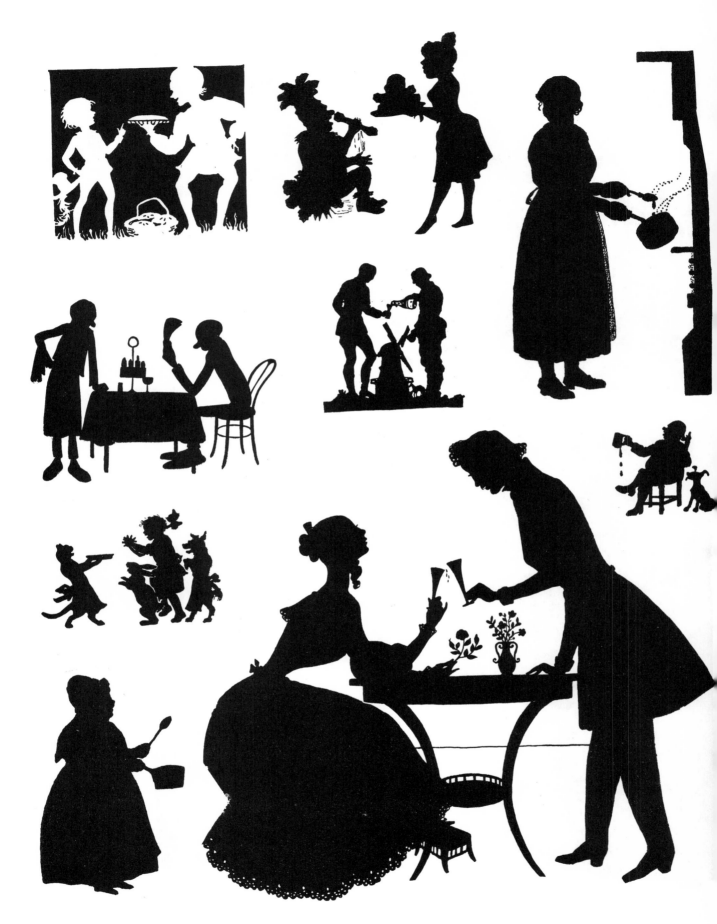

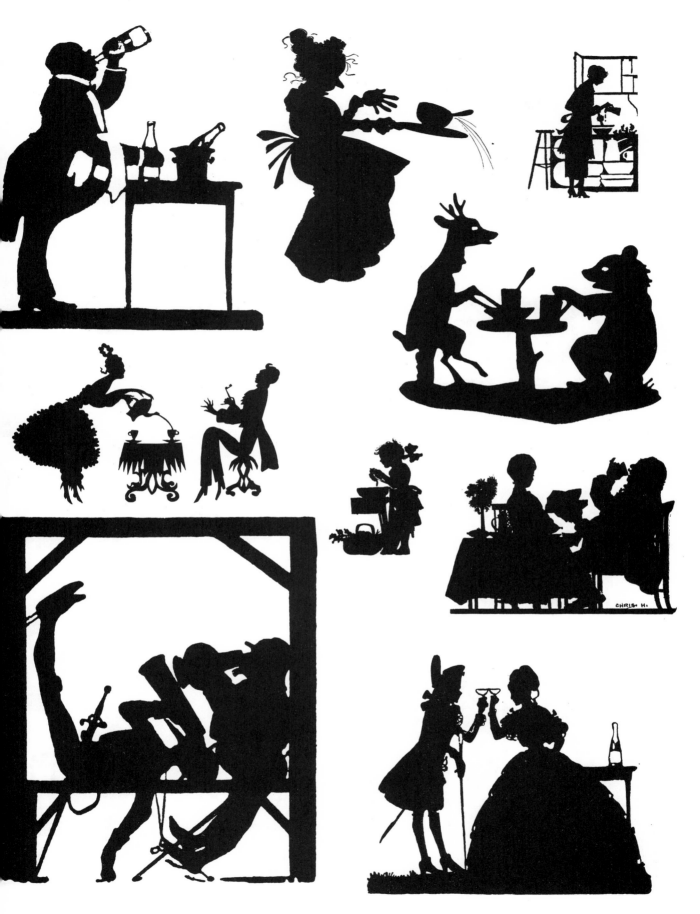

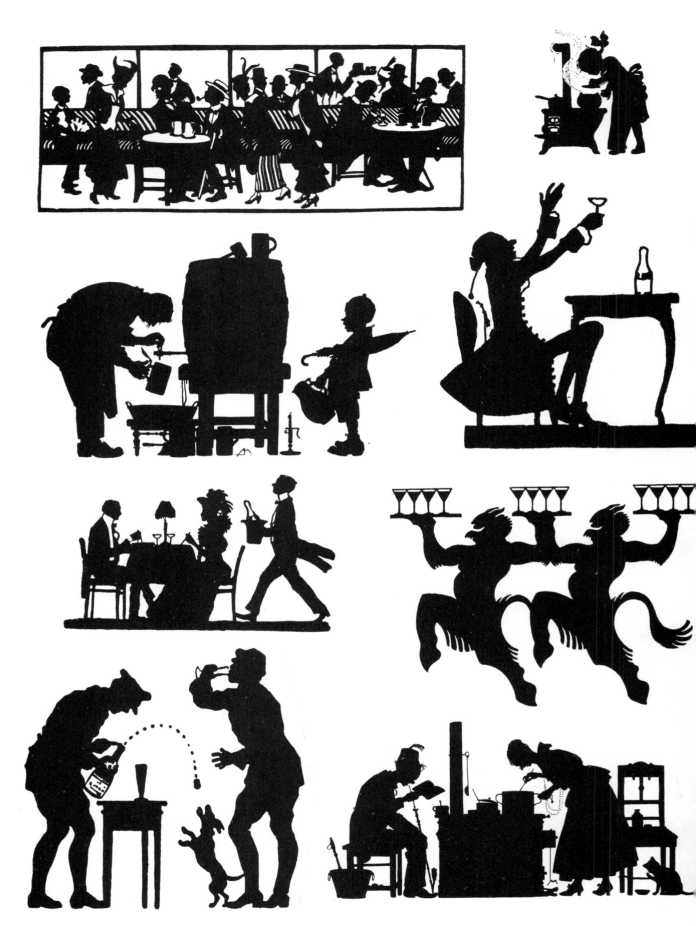

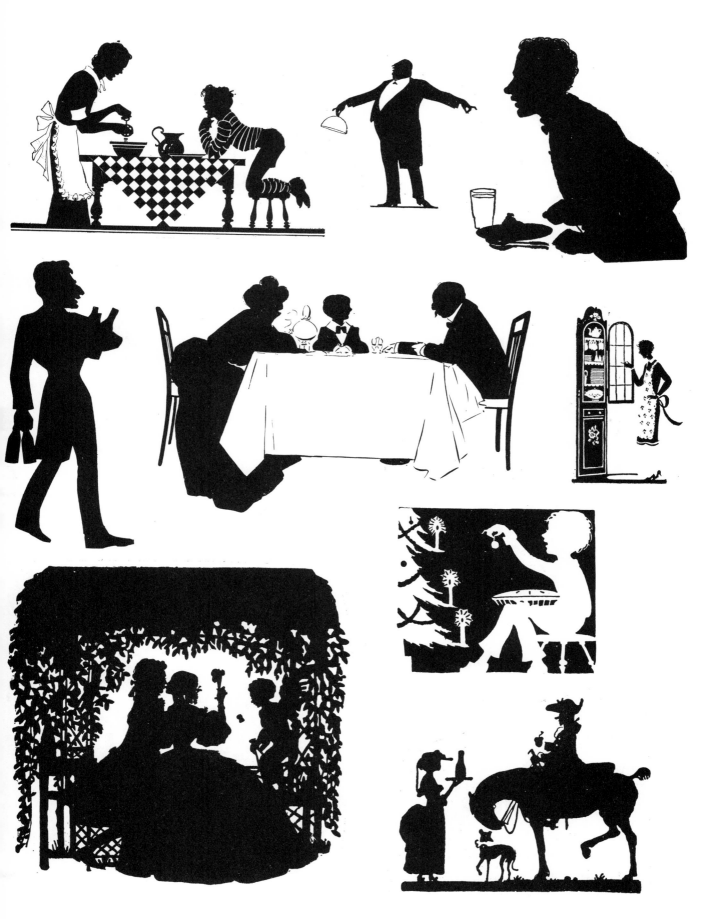

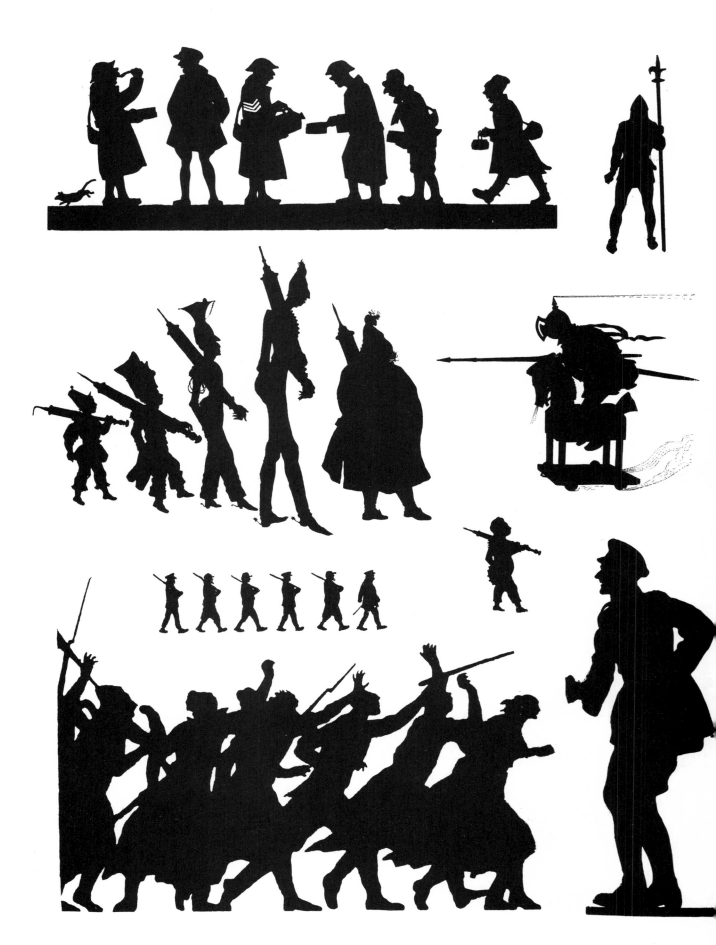

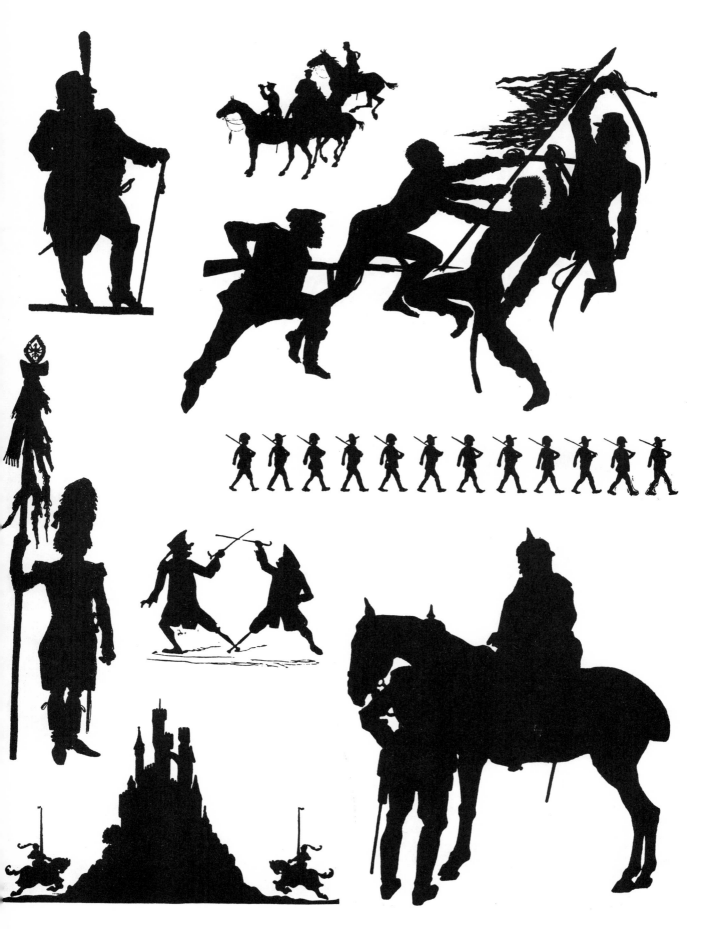

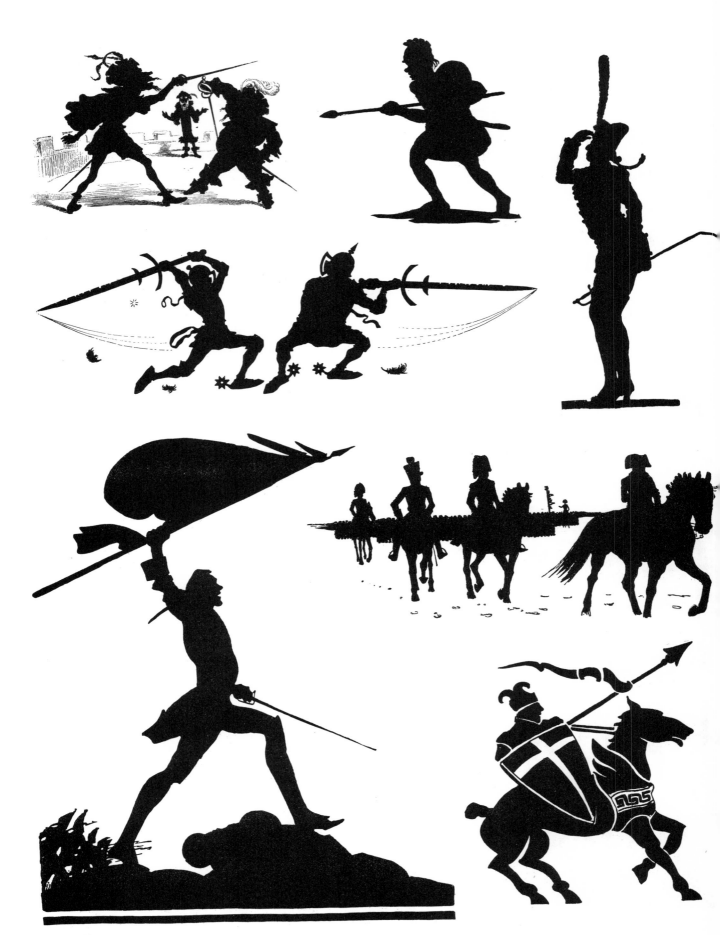

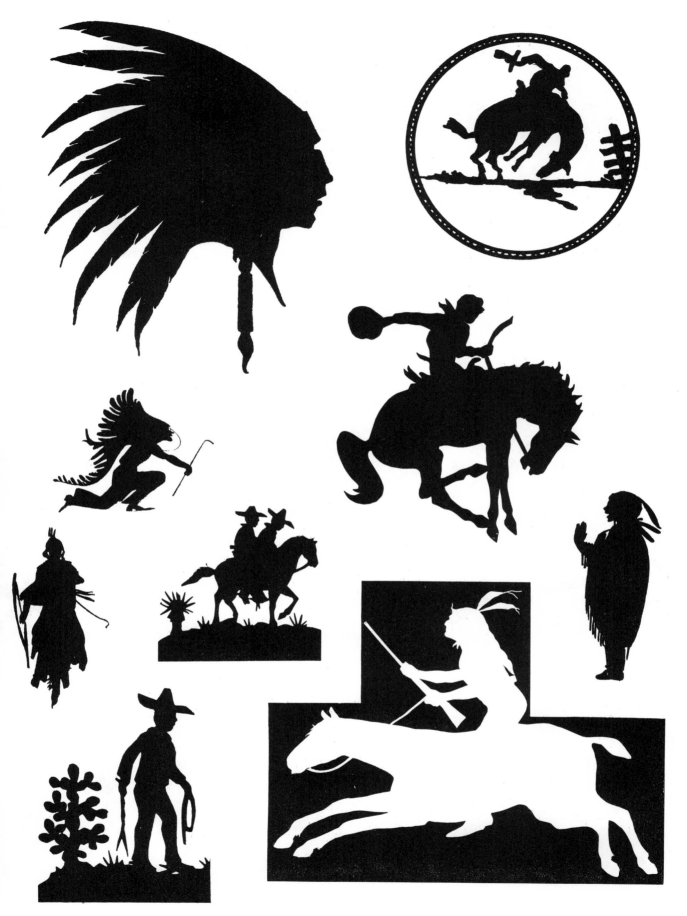

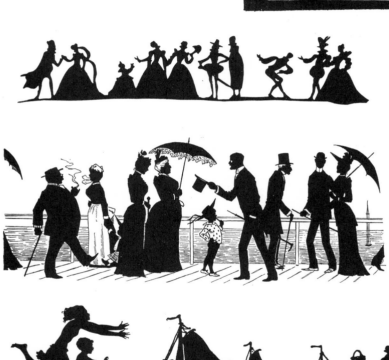

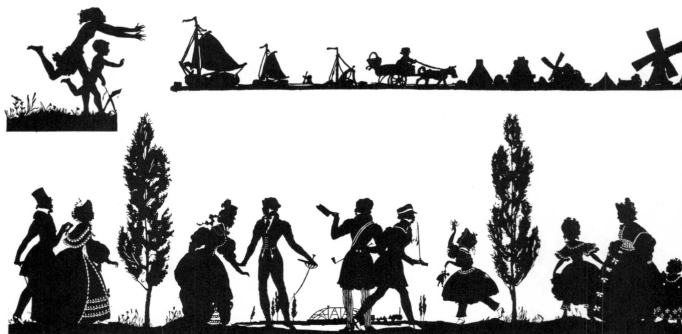

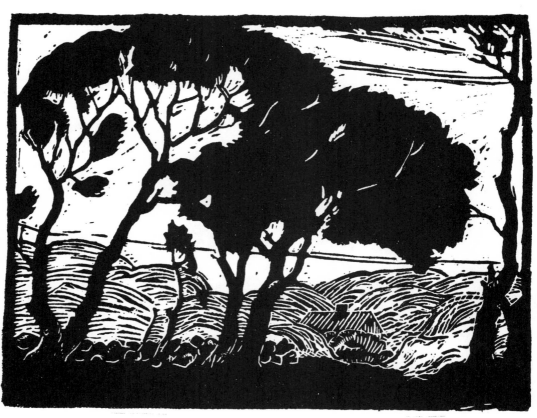

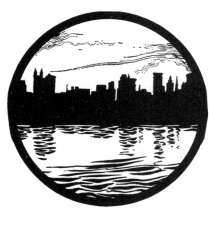

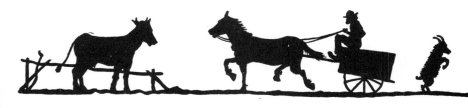

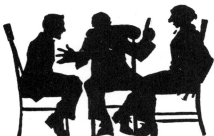

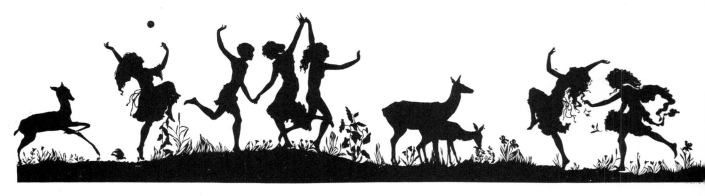

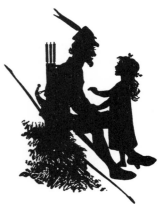
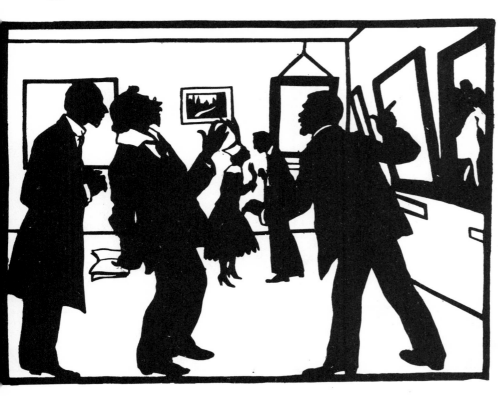

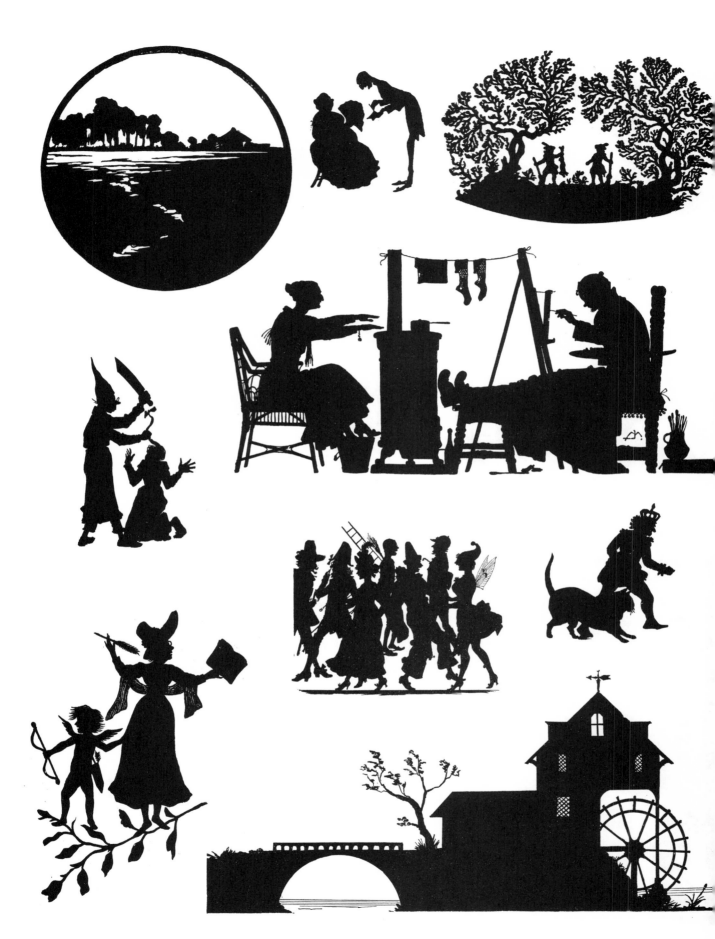

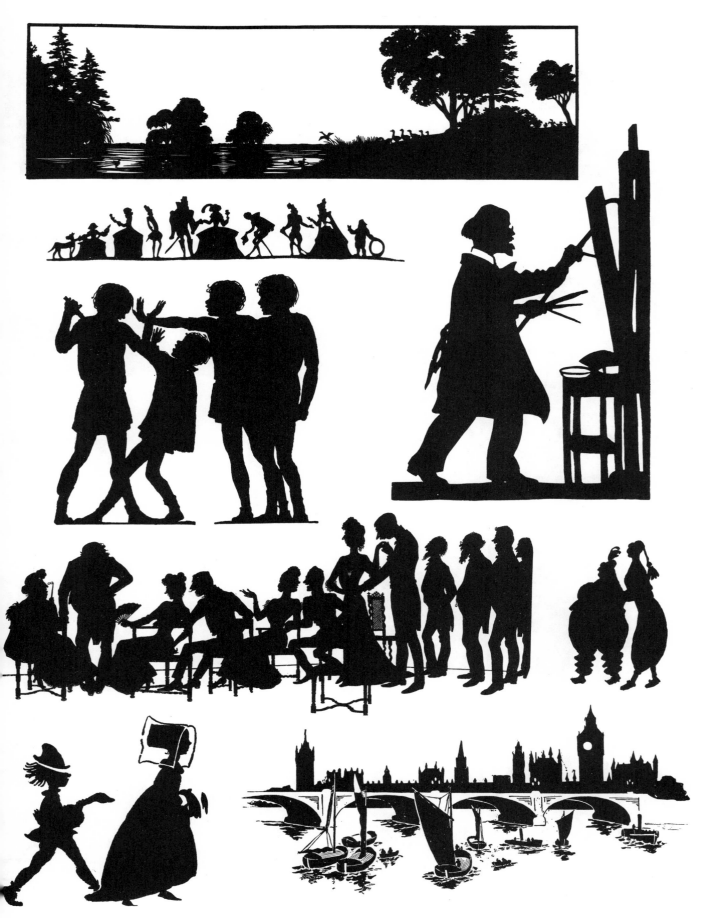

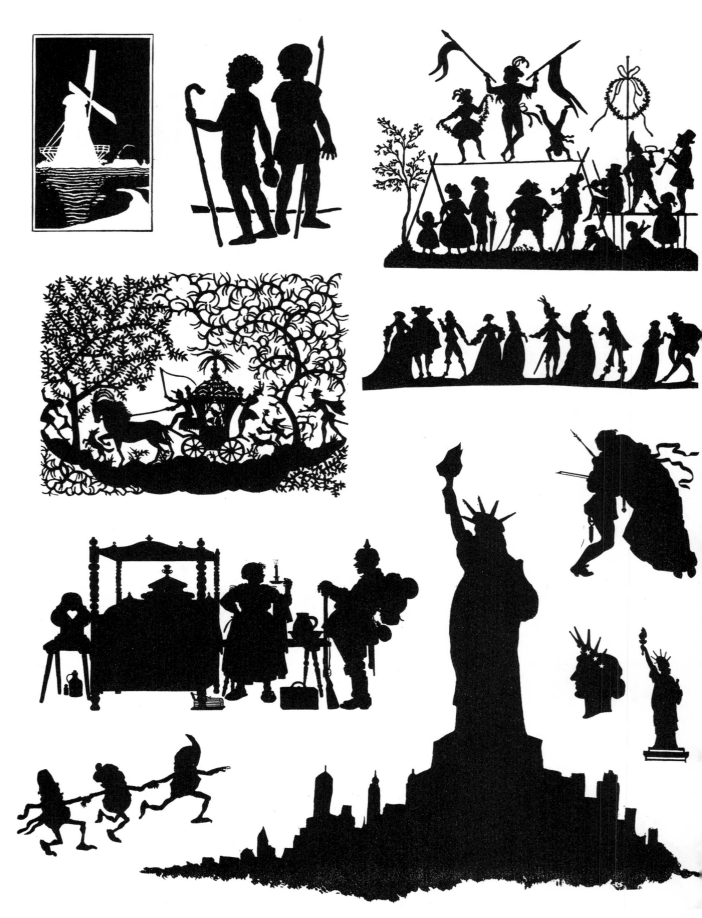

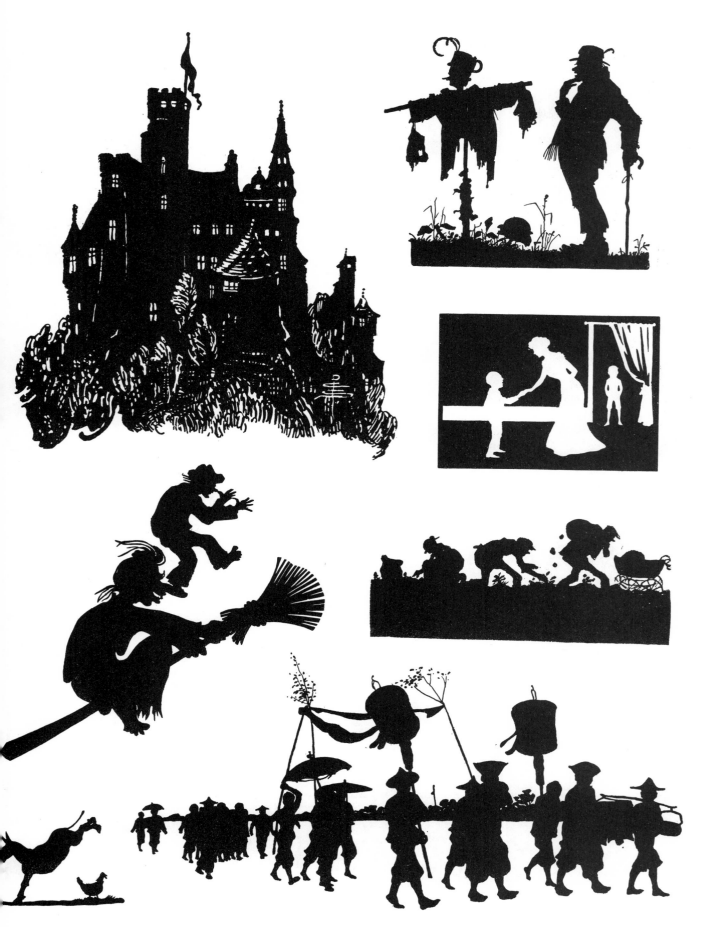

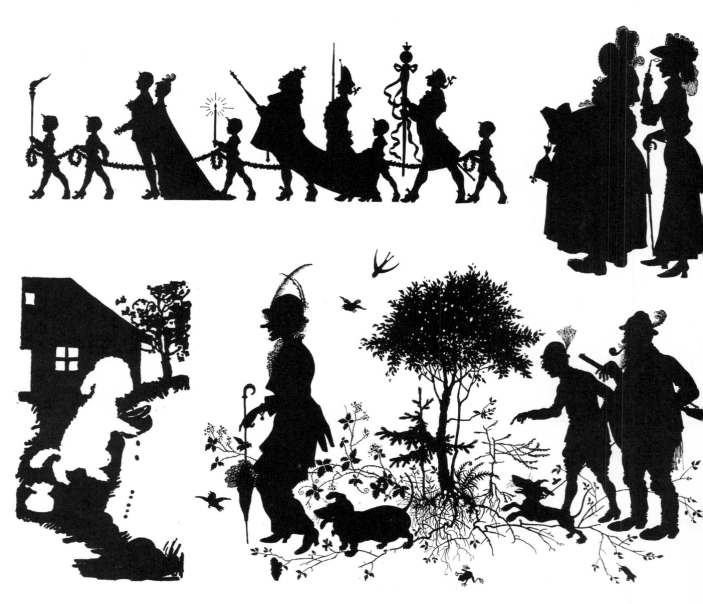

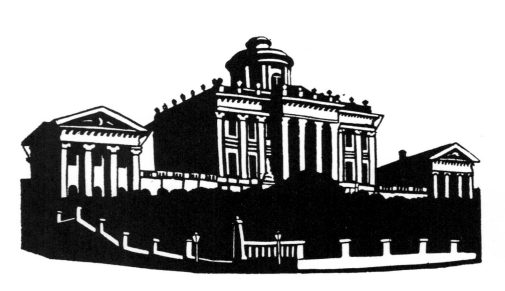

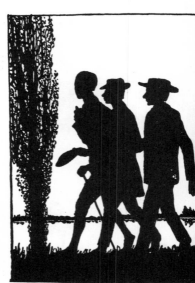

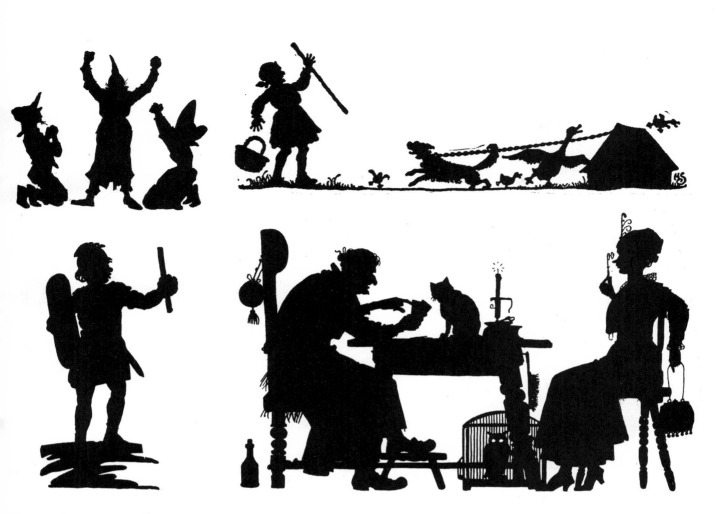

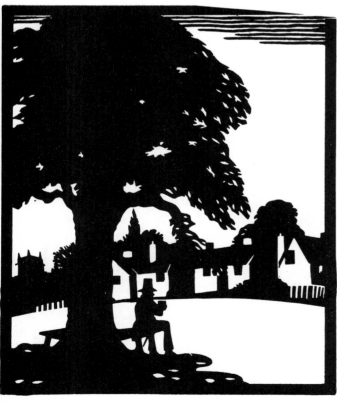

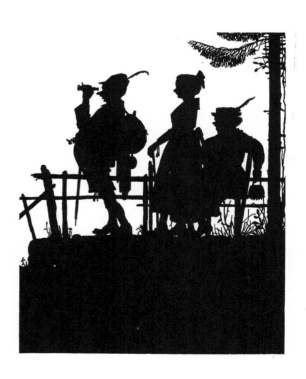

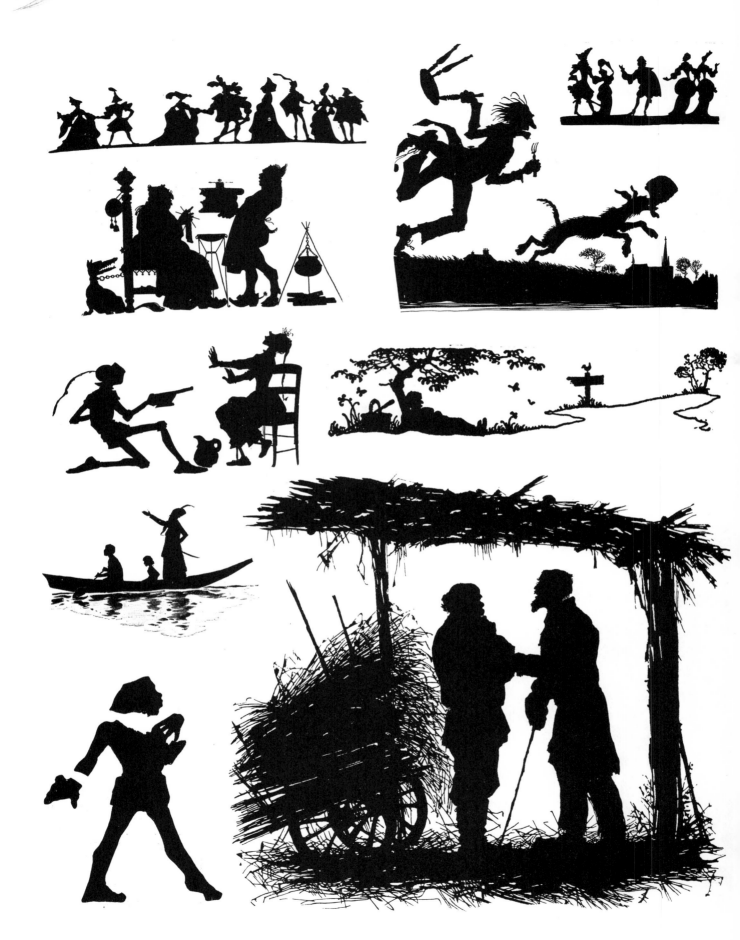

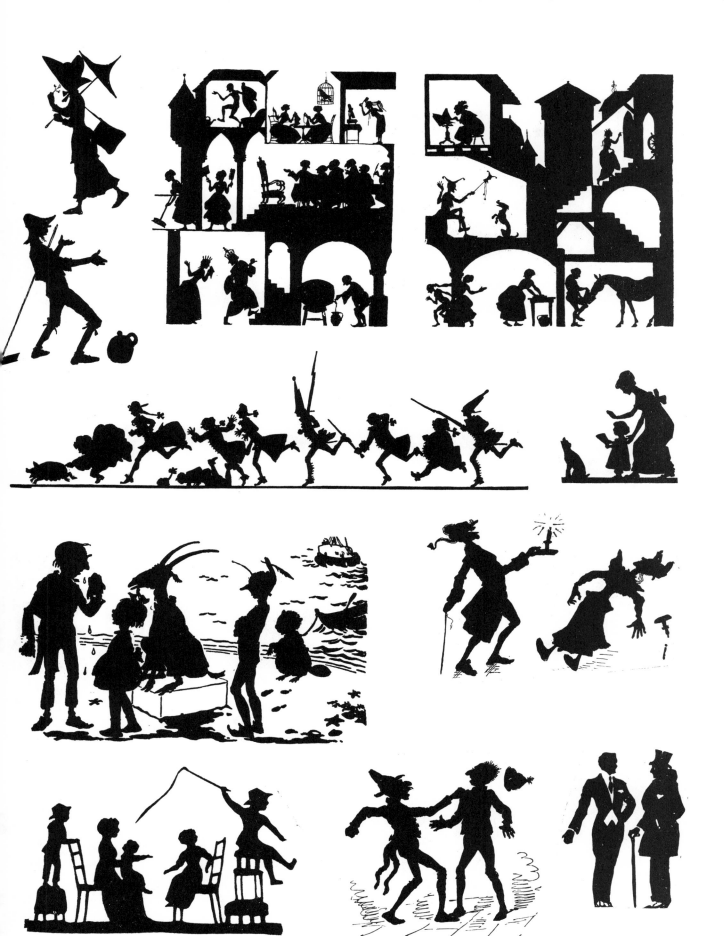

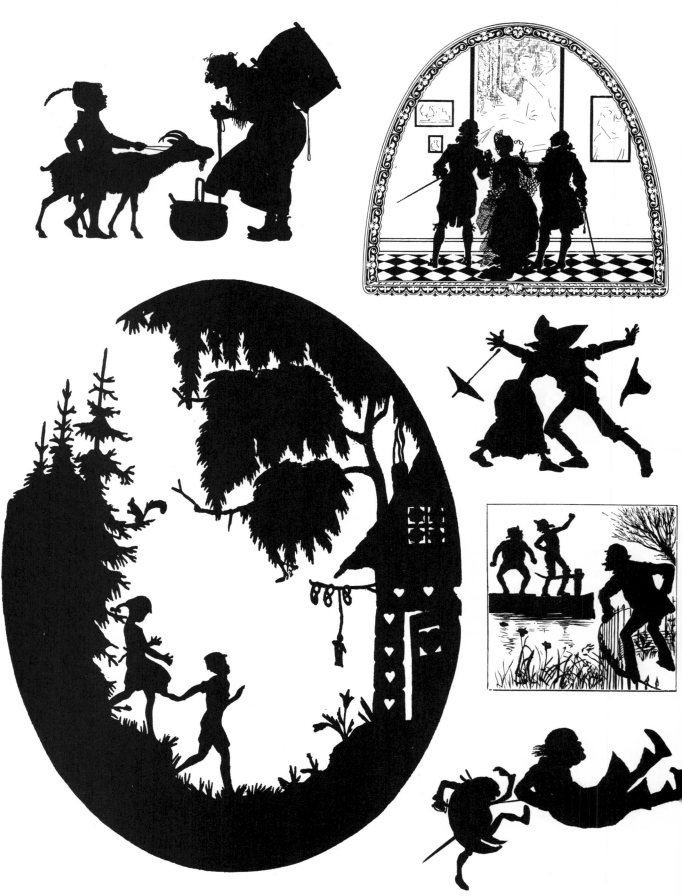

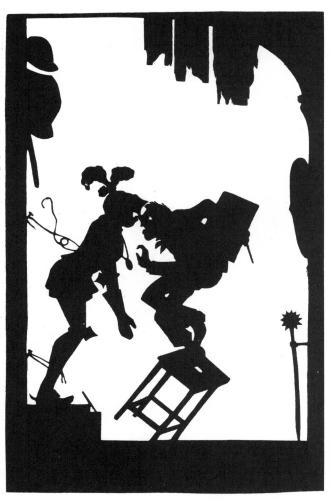

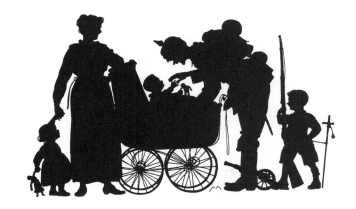

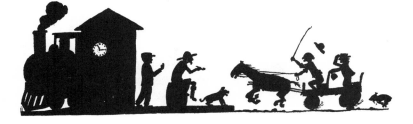

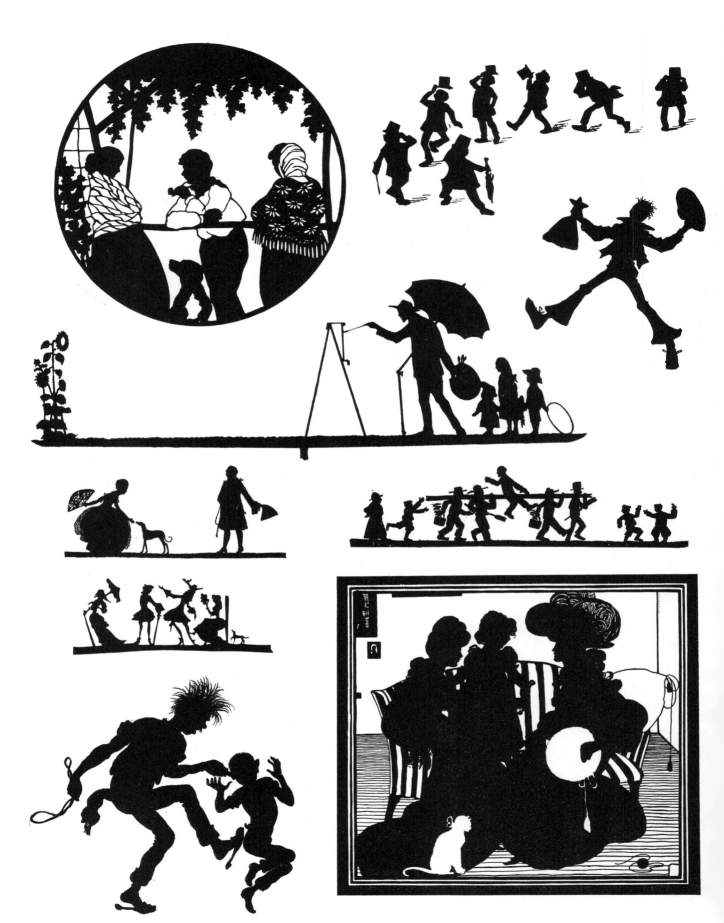

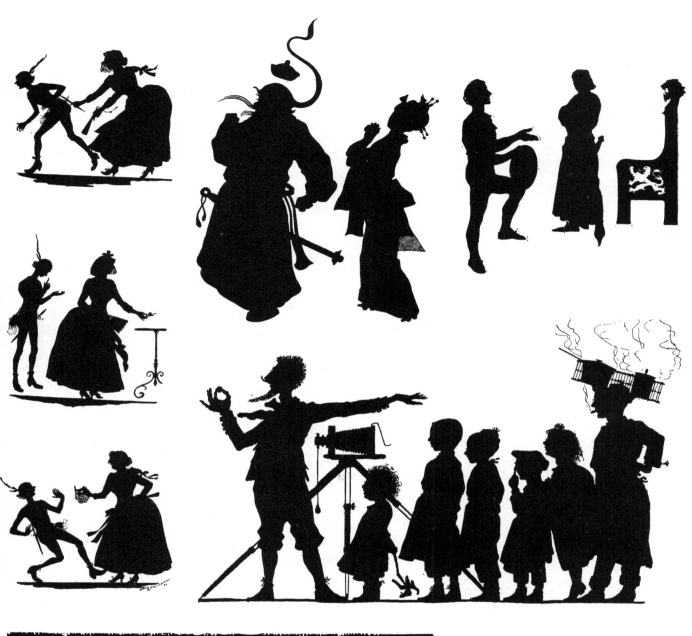

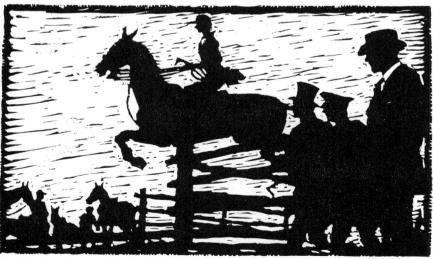

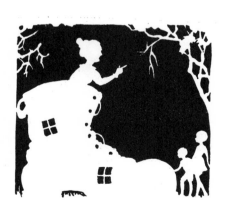

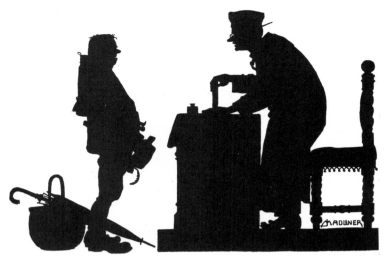

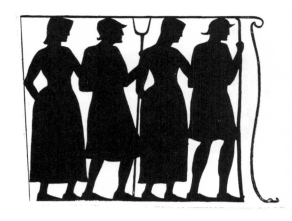

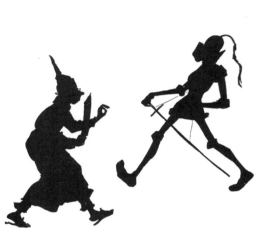

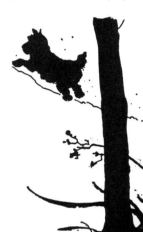

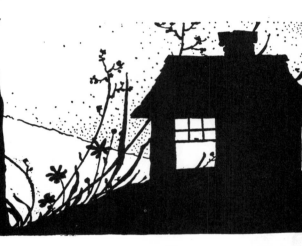

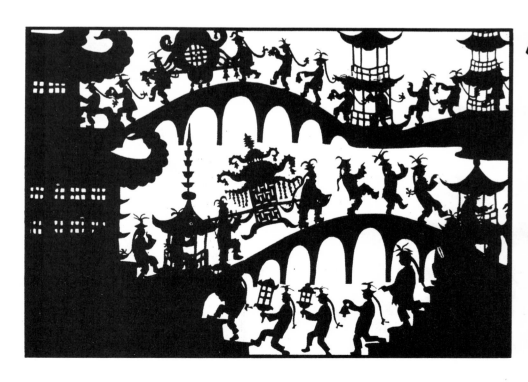

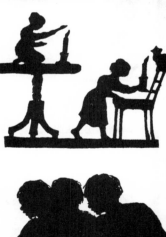

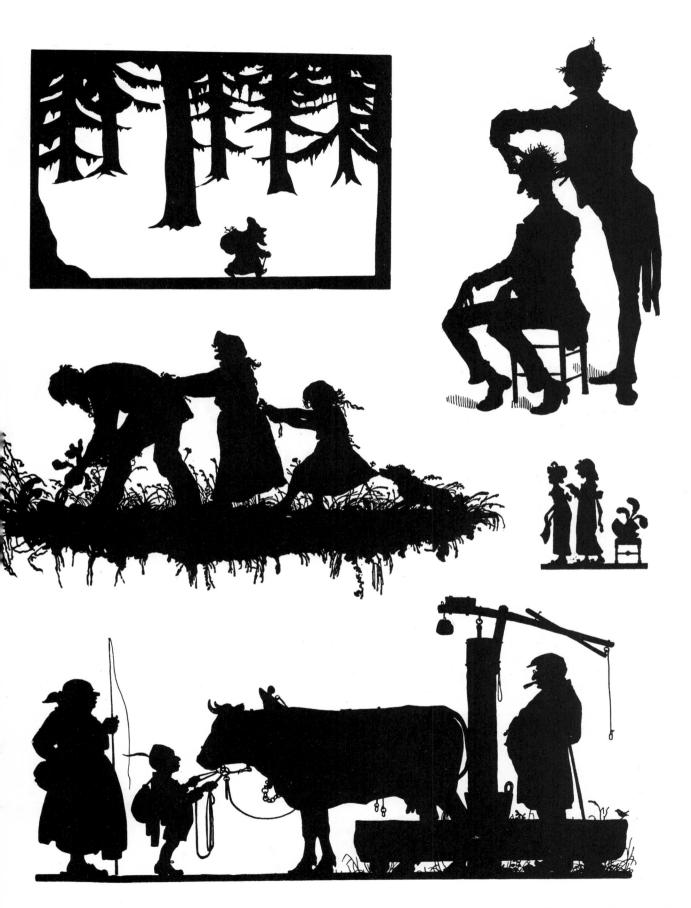

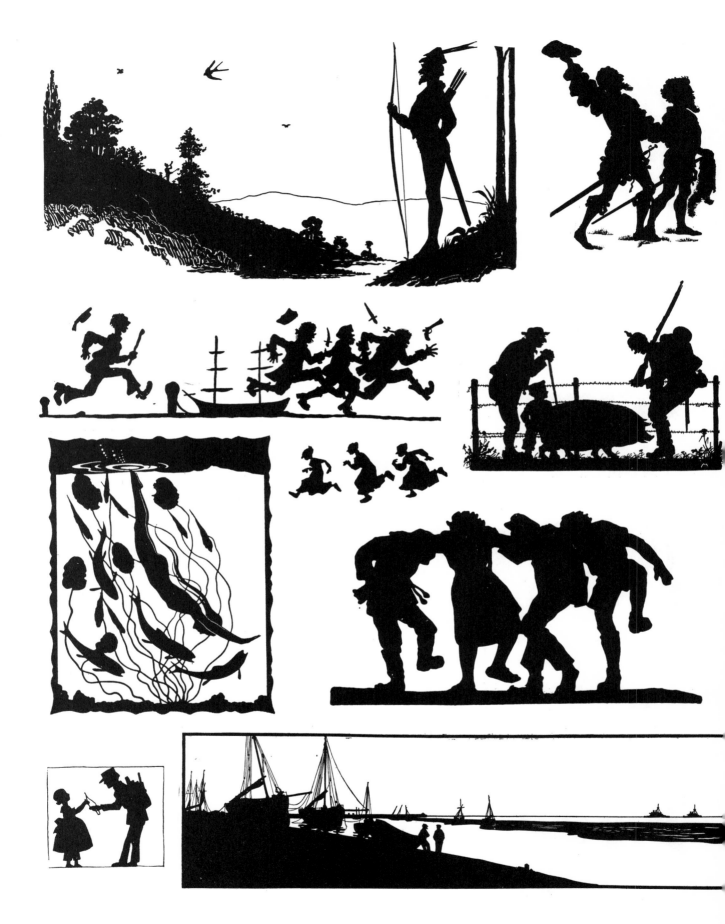

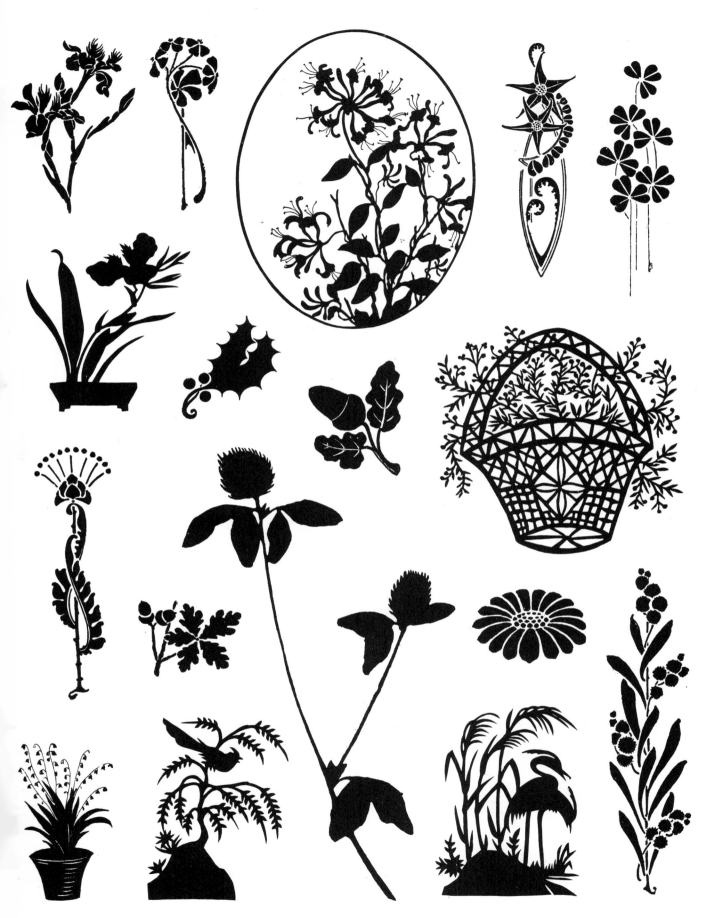

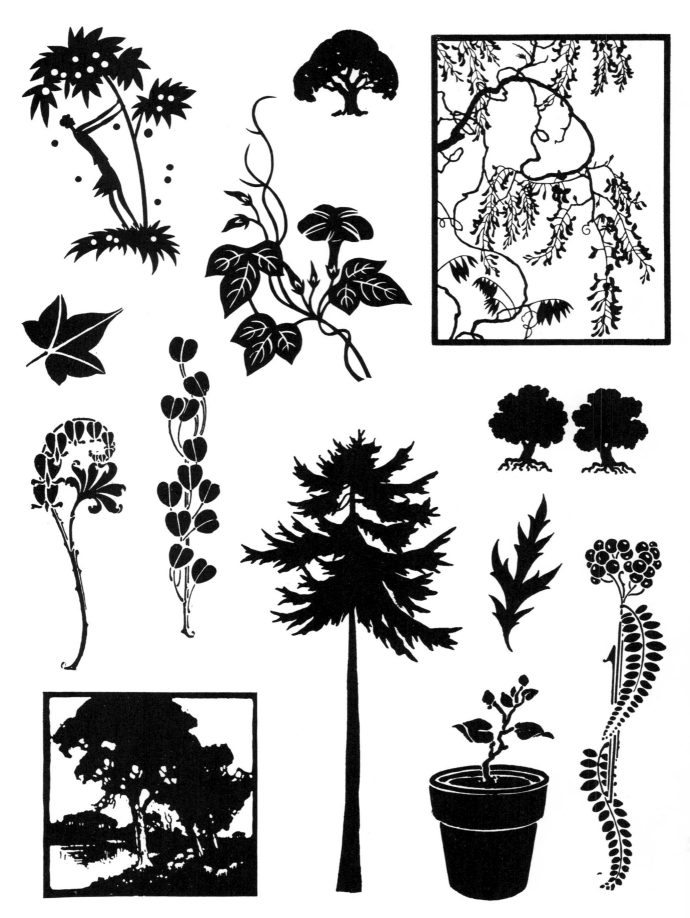

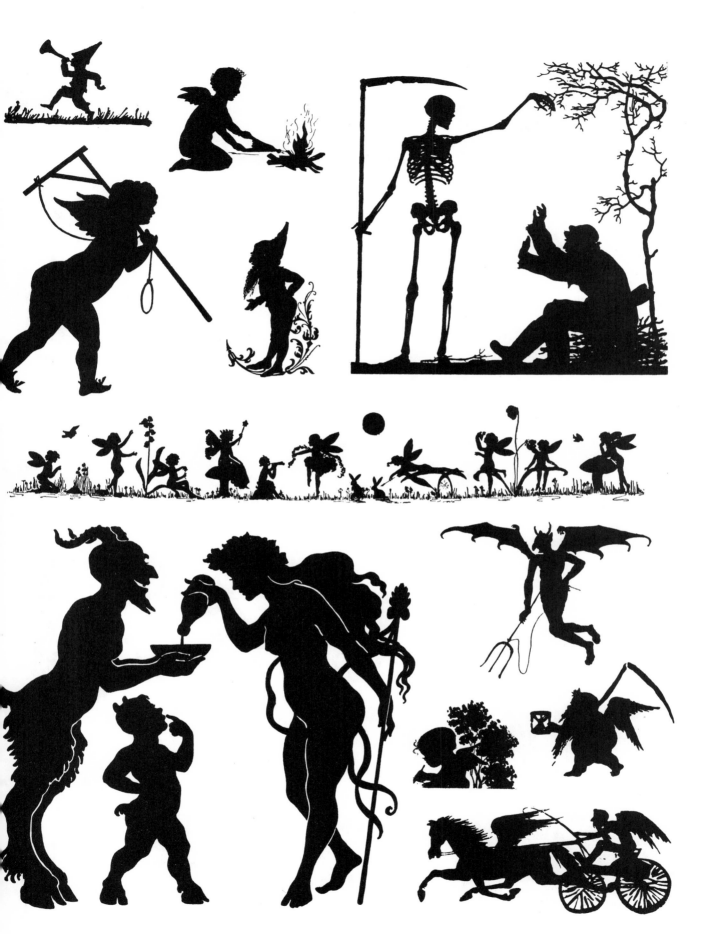

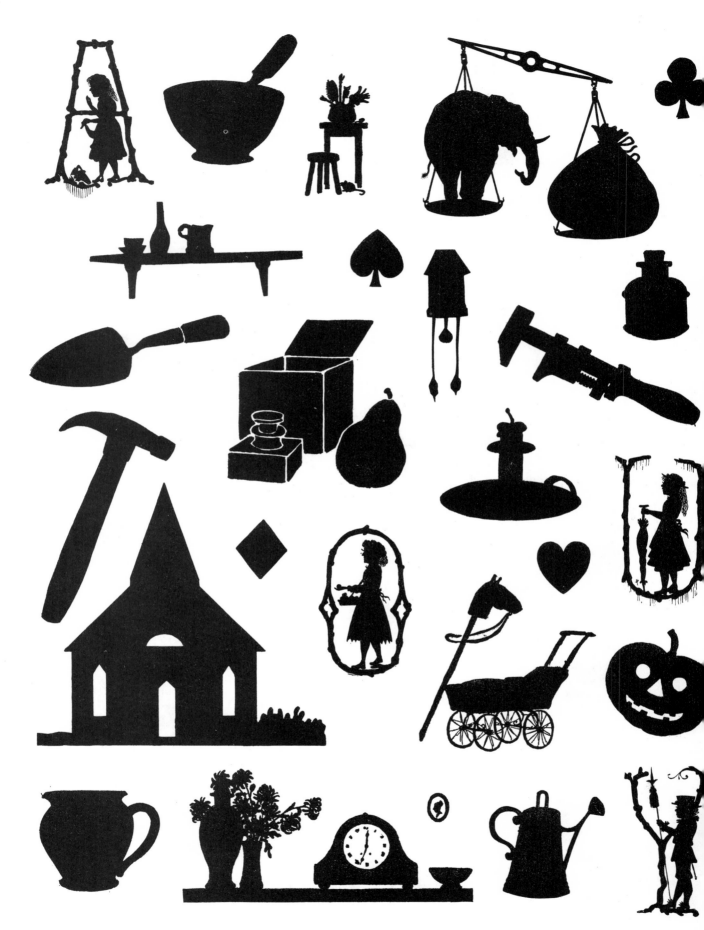